PHOTOGRAPHS

TWENTY-FIVE YEARS

KEITH

PHOTO

TWENTY-F

UNIVERSITY OF TEX

INTRODUCTION BY A. D. COLEMAN

CARTER

GRAPHS

IVE YEARS

AS PRESS ⊽ AUSTIN

SERIES EDITOR BILL WITTLIFF

Also by Keith Carter

From Uncertain to Blue (1988) was originally published by Texas Monthly Press
and is now distributed by Texas A&M University Press.

The Blue Man (1990), *Mojo* (1992), and *Heaven of Animals* (1995) were originally published by
Rice University Press and are now distributed by Texas A&M University Press.

Bones (1996) is published by Chronicle Books.

Copyright © 1997 by Keith Carter

Introduction, " 'Imagination in the Boondocks':
The Photographs of Keith Carter," Copyright © 1997
by A. D. Coleman

All rights reserved
Printed in Hong Kong
First University of Texas Press edition, 1997

Requests for permission to reproduce material from this work should be
sent to Permissions, University of Texas Press,
Box 7819, Austin, TX 78713-7819.

The paper used in this publication meets the minimum
requirements of American National Standard for Information
Sciences—Permanence of Paper for Printed Library Materials,
ANSI Z39.48-1984.

Library of Congress Cataloging-in-Publication Data
Carter, Keith, 1948–
Keith Carter : photographs, twenty-five years / by Keith Carter ;
introduction by A. D. Coleman.
p. cm. — (Wittliff Gallery series)
ISBN 0-292-71195-6 (alk. paper)
1. Photography, Artistic. 2. Carter, Keith, 1948–. I. Title. II. Series.
TR654.C3654 1997
779'.092—dc21 97-8052

Book design by D. J. Stout
Production by Nancy McMillen

This book is published with the assistance of
the Susan Vaughan Foundation, Inc.
and the Harris and Eliza Kempner Fund.

WITTLIFF GALLERY SERIES

THIS SERIES ORIGINATES FROM THE WITTLIFF GALLERY OF SOUTHWESTERN & MEXICAN PHOTOGRAPHY, AN ARCHIVE AND CREATIVE CENTER ESTABLISHED AT SOUTHWEST TEXAS STATE UNIVERSITY TO CELEBRATE THE PHOTOGRAPHIC ARTS.

● ● ● ●

I WOULD LIKE TO THANK MY WIFE, PATRICIA, SUSAN BIELSTEIN, DAVID AND PATTY CARGILL, JEAN CASLIN, STEPHEN CLARK, EVELYNE DAITZ, CATHERINE EDELMAN, DEBRA HEIMERDINGER, ROY FLUKINGER, THE LATE JOE FOLBERG AND DORIS JEAN FOLBERG, NANCY MCMILLEN, RONI MCMURTREY, D. J. STOUT, CONNIE TODD, ANNE TUCKER, HOMER AND JANE WALLES, CLINT WILLOUR, AND BILL AND SALLY WITTLIFF FOR THEIR ENCOURAGEMENT THROUGHOUT THE YEARS.

KEITH CARTER

FOR MY MOTHER

JANE DAVIS GOODRICH

LIST OF TITLES

1 ATLAS 1996

• • • •

EARLY WORK

2 TOY WITH NO CHILD 1972

3 PINE SPRINGS CAFE 1974

4 PATRICIA 1979

5 BOY WITH BARITONE 1981

FROM UNCERTAIN TO BLUE

6 OATMEAL 1986

7 NOONDAY 1987

8 PARADISE 1988

9 UNCERTAIN 1986

10 DIALVILLE 1986

THE BLUE MAN

11 HUMMINGBIRDS 1989

12 MEAGAN 1988

13 JACK WITT 1987

14 GISELLE AND POPEYE 1987

15 CHURCHWOMEN 1989

16 ELIZABETH AND SNAKE 1989

17 COYOTE 1989

18 FOX HARRIS 1984

MOJO

19 GARLIC 1991

20 FIREFLIES 1992

21 BOY WITH BEE 1990

22 ATLAS MOTH 1990

23 DOG GHOST 1990

24 LOST DOG 1992

25 RAYMOND 1991

26 GEORGE WASHINGTON 1990

27 MUD LOVERS 1990

HEAVEN OF ANIMALS

28 WHITE BIRD 1992

29 ALICE 1994

30 ORANGE TREE 1995

31 WHITE SHOE 1994

32 CHICKEN FEATHERS 1992

33 OPEN ARMS 1993

34 MEAGAN'S NEW SHOES 1993

35 JESSAMINE'S GOWN 1994

36 THE WALTZ 1994

37 SLEEPING SWAN 1995

IMAGINATION IN

THE PHOTOGRAPHS OF

THE BOONDOCKS

KEITH CARTER

BY A.D. COLEMAN

Reading a recent anthology of short fiction about photographers and photography reminded me once again that most creative writers—those who work in the modes of fiction, poetry, and drama—have tended to treat photographers as a breed of people intellectually and morally inferior to and different from the rest of us. Or, at least, lesser than and definitely apart from writers like themselves, implicitly engaged in some higher, nobler calling.

Indeed, the bulk of the fiction and poetry on this subject up till now deals mostly in stock characters: the abrasive and intrusive paparazzo, the furtive Arbus-like ferreter-out of closet skeletons, the unwholesome fetishist, the brash insensitive portraitist, the intrepid *National Geographic* image-monger. Excepting the last, most of those made their appearances in the anthology I perused, in predictable versions that did not notably stretch the genre. Even when well-written, like the selections from Cynthia Ozick, Alberto Moravia, and

Italo Calvino, they added nothing to our understanding of the medium or of its practitioners, instead using them as convenient whipping boys for the writers' all too apparent unease.

Unease with what? Unease, I suspect, with what Dylan Thomas called their own "craft and sullen art," which has much in common with the work of any photographer who moves beyond the semantics of the medium into its poetics. Once one begins creating photographs that are *about* something over and above what they are *of*—as soon as one steps out of the literal and ostensibly transcriptive into the territory of the metaphorical—then issues familiar to creative writers require attention: compression, heightened language vs. vernacular usage, formal structure (or the seeming lack of it), narrative style, narrator's point of view, the theatrical frame, close observation of particulars, rhythm, tone, voice. Not to mention such commonplace authorly practices as making art out of everyday experience, or betraying the confidences of one's intimates and loved ones by transforming minimally their deepest fears and secrets and presenting those to the eyes of strangers in the transparent guise of total invention, effectively laying them naked before the world.

To be fair, not all writers manifest that antipathy to photography itself, or to those who work with light and lens. George Bernard Shaw became an avid amateur pictorialist; August Strindberg experimented with and philosophized about the medium; Eudora Welty dabbled in it, as did many others, from Karel Capek to Allen Ginsberg. Famously, too, Jack Kerouac wrote of Robert Frank's *The Americans* that the Swiss-born photographer had "sucked a sad poem right out of America onto film, taking rank among the tragic poets of the world," asserting that "Anybody doesn't like these pitchers don't like potry, see?" Still, I'd be hard-pressed to cite an imaginative representation in prose, poetry, or theater of a photographer as a meditative, responsible, ethical, committed creative artist, as worthy as any other of our full respect—someone, for example, resembling Keith Carter, a synopsis of whose achievement to date you hold in your hands.

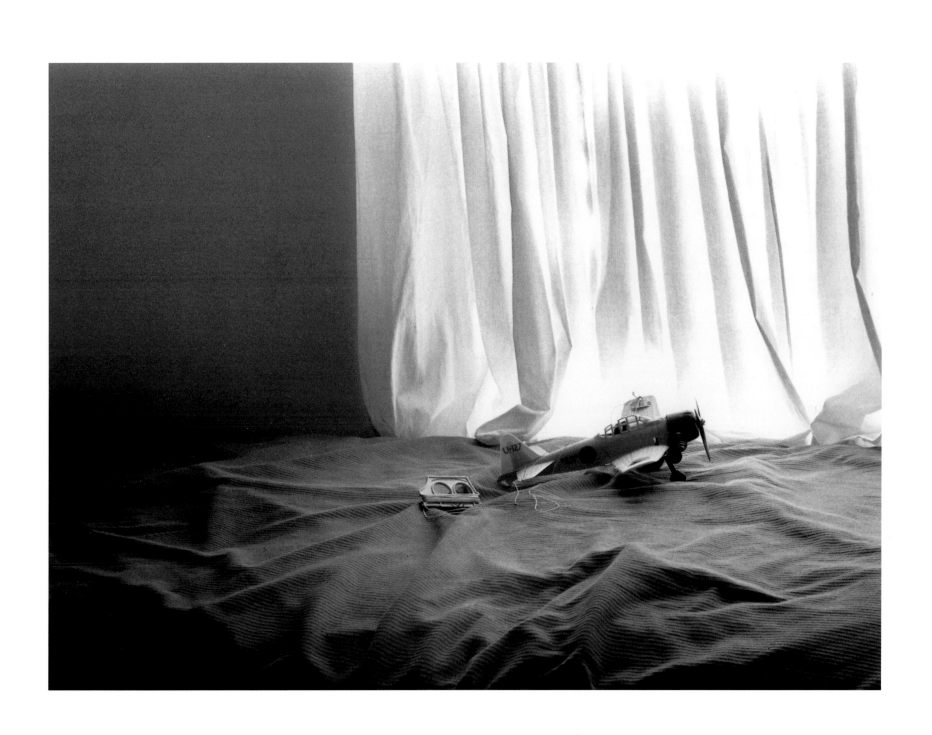

Perhaps the frequent antagonism of writers to photography and photographers, then, functions as a form of denial, a refusal to acknowledge complicity and even kinship, a reluctance to confess something seen as guile and guilt. Notably, photographers (at least in my experience) do not return that disdain, hostility, and suspicion. Not that they necessarily see writers as superior beings; but I have never heard a photographer disparage creative writers generally, or writing as such (though some do not hesitate to point out the medium's limitations, and a few manifest the insecure artist's resentment of critics and criticism). To the contrary, I have met a considerable number of photographers—Carter certainly among them—who love resonant writing and admire those who produce it, who have read both widely and deeply. Several of the closest readers I've ever had myself have been photographers, who proved themselves capable of perceiving and articulating the nuances of changed meaning that the substitution of a single synonym could effect. Why would one expect anything different from people who devote such concentrated attention to the subtleties of shape and tonal structure? In fact, not a few of them turn out to be highly capable (if often closeted) writers themselves—including the one represented by this monograph, though I know he will refuse the compliment.

For reasons I cannot explicate, not coming from that region myself, photographers from the southern United States seem to embrace unabashedly that relation to literature. I think here of Clarence John Laughlin, and Ralph Eugene Meatyard, and Lyle Bonge, and, of course, Keith Carter: photographers who read, whose thoughtful relationship to spoken and written (and sung) language has in turn shaped their thinking and feeling and seeing, who aspire to create something that could without apology demand consideration as a photographic equivalent to literature. Photographers who, moreover, can be seen as emergent from and contributory to that deep, rich vein of literature from the southern United States, the tradition that incorporates William Faulkner, Flannery O'Connor, Davis Grubb, and so many more (including, if I had my druthers,

Robert Johnson, Lightnin' Hopkins, Charlie Patton, Son House, and the other fountainheads of southern Black oral history in song).

Like all of these, Keith Carter began his true work by accepting his own chosen geographical location—East Texas—as entirely sufficient for his purposes. A less simple matter than it sounds, this meant looking neither to the urban centers (particularly in the north) nor to Europe and the international image community for what would nourish his work and serve as its benchmark, but instead seeking its spiritual sustenance within driving distance of where he lived, probing for what he once termed "imagination in the boondocks." The specific here and now of where he'd chosen to live and work thus became his fundamental subject matter.

He has spoken of finding himself unexpectedly alerted to the personal necessity of this premise by a comment of Horton Foote's, offered by that writer during the course of a public lecture. Whether that decision was made consciously or intuitively, one can see the initial results of it in the images Carter produced during the second half of the 1980s and published in his first collection, *From Uncertain to Blue* (1988), a monograph organized on the literal level as a survey of small Texas towns. These photographs evidence a search for the spirit of place, a profound respect for the muscular, relentless aspects of the Texas terrain and the light that batters it, a delight in its occasional fecundities and darknesses, an uncondescending admiration for those who inhabit it and (as much as humans can) make it their own.

At the risk of presumption, I'll suggest that it seems Carter did not yet truly know himself to be one of them. Thus that book feels more like the staking out of a territory than the actual occupying of it and making oneself to home. Though produced with the same equipment and materials he has continued to use—a single-lens reflex camera that provides

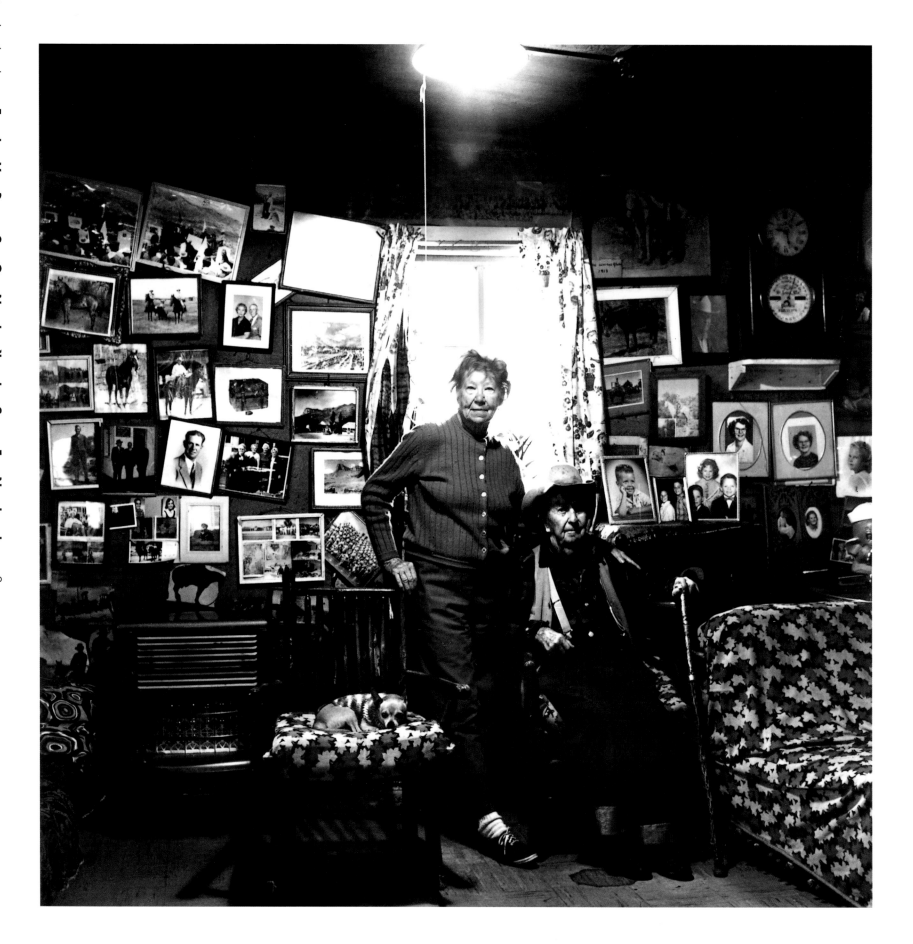

a 2¼" square negative on black-and-white film—these images seem different not only in quality but in kind from what succeeded them. Highly formal in structure, predominantly classical in style, deliberately static, made (for the most part) at a considerable distance from their nominal subjects, their descriptive strategies were restricted by and large to the illusion of straight transcription, their dramaturgy subdued almost to invisibility. Intelligently seen, finely crafted, sympathetic to what they addressed, these pictures build on but do not significantly extend or depart from the documentary tradition in photography as expounded more than half a century ago by Walker Evans, Dorothea Lange, and others of that generation. If Carter understood as he made them that, as he put it, he traversed and scrutinized "a landscape that knows how to keep a secret," he had yet to learn to allow it to speak its heart, or give himself permission to do the same.

Somewhere shortly after that book's publication, Carter appears to have undergone an internal tectonic shift. He himself ascribes it to the epiphany of hearing casual mention of "the blue man"—a neighbor, their former local butcher, with genuinely blue skin—in a discussion between his wife, her cousin, and her mother. As a result, he recalls, "I . . . started looking at where I lived as an exotic land, almost as an allegory." Yet that does not fully explain the change in his imagery. Others before him, like Laughlin and Meatyard, had addressed the mythology of the south, its dense exudations and resonances, its rot and fertility, its atmosphere at once enchanted and haunted, and the effects of all that on those who live there, without altering the way their pictures looked.

Whatever happened to him or he did to himself at that juncture, Carter started handling his camera differently. This should be understood as neither a minor nor a purely technical matter. The selection of tools, materials, and processes, and the decisions regarding how to employ them, shape and to a considerable extent determine what one might call (to borrow a term from literary criticism) a photographer's "voice."

Carter had already settled on the Hasselblad, a single-lens reflex camera, as his instrument of choice. Bulkier, heavier, and somewhat slower to operate than a 35mm camera, it generates a square negative several times bigger than the rectangular negative of 35mm film. As an instrument, it has some distinct advantages over its smaller relatives. The larger negative size means that in a print—even a considerable enlargement, such as the 15-inch-square ones Carter favors—one will find more detail, with less distractive intrusion of visible grain; thus the interpretive printmaker (and Carter is one such) can render the subject large, sometimes even close to life-size, while still effectively maintaining the illusion that the frame of the image is merely a threshold over which the mind and eye of the viewer can freely step. Moreover, this camera provides the flexibility of a hand-held tool, plus the visual stability and formality of the square over the rectangle as a framing shape. For subject matter that holds still, or for things that move but not too quickly, it's ideal. Unlike the 35mm, this is not a hunter's camera but a gatherer's, not a bow and arrow but a sieve.

Many if not most of the images in *From Uncertain to Blue* appear to have been made with the camera fixed on a tripod. This of course eliminates any shaking of the instrument by the bodily motions of the photographer, a trace of the operator behind the machine. It also literalizes the idea of fixed-point perspective, physically immobilizing the camera and its user, whose stasis tends to infiltrate the image. In combination with the stability of the square format, and an inclination toward central placement within the frame of his primary subject, that led Carter almost inevitably to traditional solutions for pictorial problems.

Carter, who then still earned his living—as had his mother before him—working as a studio portraitist, had become habituated to using this crutch; nonetheless, he started to set it aside. By abandoning the tripod with increasing frequency, the photographer accepted, even courted, the risk of registering on the film evidence of his own presence, visual manifestations of the inevitable subjectivity of photographic seeing. This bespeaks a

mounting trust in himself as a communicating perceiver. At the same time, he freed himself for a more fluid, cinematic, gestural response to whatever he found before his lens. More and more often, as a result of this loosening of strictures, he chose to observe his microcosms from unpredictable vantage points, such as the approximate eye level of his smaller subjects, children and animals.

Simultaneously, he began to decrease considerably the previous physical distance he'd tended to place between his subjects and himself. The late combat photographer Robert Capa once said, "If your pictures aren't good enough, you're not close enough," an insight that photographers as different from him (and from each other) as Man Ray and Ralph Gibson have profitably applied to their own picture-making ends. In Carter's case, this same understanding brought him more and more often within touching distance of what he photographed, a visual analogue of involvement, intimacy, and vulnerability.

Amplifying this, his relationship to depth of field also transformed itself. Those early images were almost all entirely devoid of foreground-background relationships; everything stands in the middle ground or behind it, presented entirely in sharp focus. Because this is not the way the human eye sees, but is instead a possibility of representation offered by the camera and lens, it has in its reminder of the mechanical nature of the photographic process an emotionally distancing effect on the viewer. (The debate among photographers over this core issue goes back to Peter Henry Emerson in the late 1800s, by the way.) Suddenly, Carter began to incorporate foreground elements into his images—everything from tree branches to dogs' noses—and to focus selectively within the psychologically deeper, more haptic space that this strategy generated. This renders the symbolic space of the image ambiguous and dreamlike, often unsettling, demanding interpretation. Consequently, in engaging with these more recent images, the viewer finds himself or herself feeling less like an outsider to the scene described, examining it at some safe remove, and more a participant, present in the

tactile context of the event, seeing it from an insider's vantage point, with the sense of immediacy, excitement, and (sometimes) dangers that such proximity evokes.

Clearly, Carter also then felt confident enough to speak more fragmentarily and elliptically, to let the part stand for the whole, to entice the viewer into deciphering the implied relationships within the image, offering clues where previously he had built airtight cases.

Which came first here, the chicken or the egg? Did some development in Carter's psyche provoke a new way of seeing and working, or did some alteration of his working method release some latent expressive inclinations? I cannot say, am not sure whether Carter himself knows (I haven't asked him), and don't think it much matters. What does is that, with the publication of *The Blue Man* (1990) a mere two years later, this stylistic and structural evolution had begun to manifest itself clearly, and a truly distinctive body of work started to emerge. Idiosyncratic, highly personalized, emotionally charged, dramatic and fabulist in its tendencies, it looks like no one else's (including that of Carter's proclaimed models, Henri Cartier-Bresson and Eugene Atget), though it has things in common with work by some of his contemporaries, notably Nancy Rexroth, Debbie Fleming Caffery, and Sally Mann.

No accident, I think, that the closest analogues that occur to me are women photographers. Indeed, if the Jungian concept of masculine and feminine aspects as inherent to every psyche regardless of gender might be applied here, I'd suggest that Carter somehow unlocked the feminine within himself during that two-year span at the tail end of the '80s. If so, that would also go a long way toward explaining his increasing attention to women, children, animals, and nurturance, which became central subjects for him between that first book and the present. Not that the work turned inward, or became directly autobiographical; there's little of that here, though the progression consistently has moved away from the detachedly observational and towards the personal and interpersonal, the conversational, the dialogic. But what seemed—or could easily have been mistaken

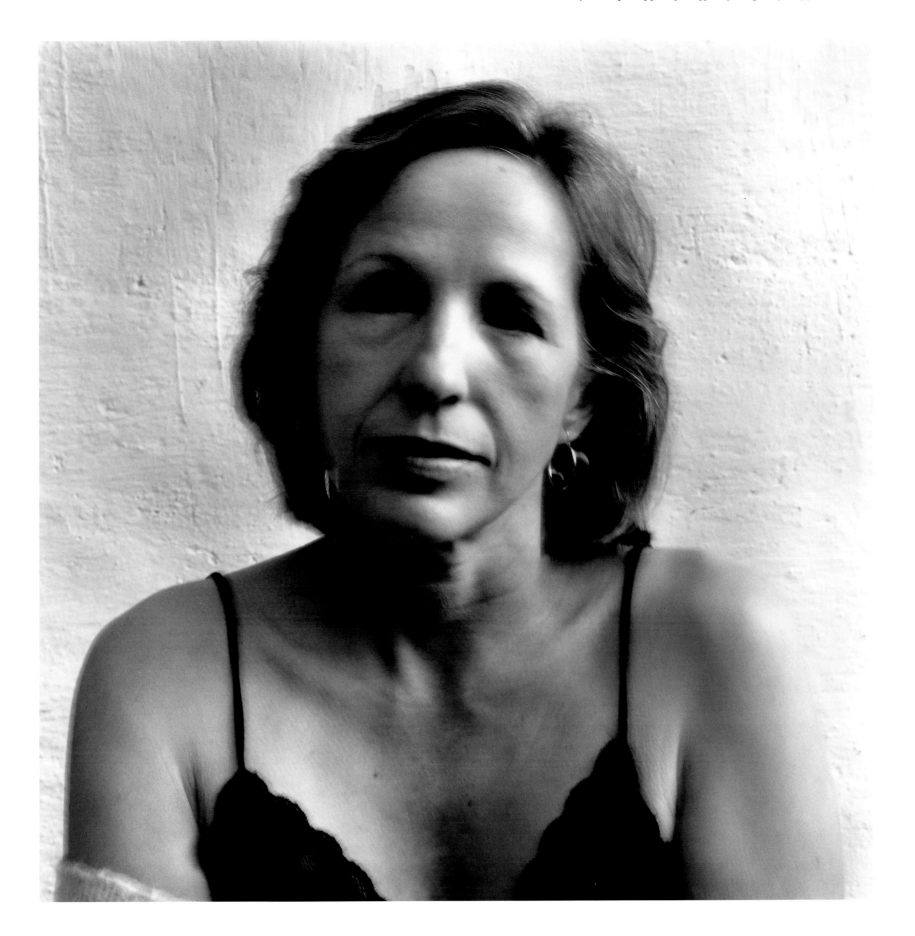

for—an emotionally detached sociological impulse in his debut project underwent a redefinition, a stripping down to essentials: humans and animals, alone and in small groups, and the temporary marks and relics they leave on the land they inhabit, have become sufficient raw material for his purposes, his engagement with them deeply felt, his definition of himself as intimately related to them made manifest.

This reduction to basics seems so extreme that, in *The Blue Man* and the two monographs that succeeded it—*Mojo* (1992) and *Heaven of Animals* (1995)—I can find only one landscape as such, only one image that scrutinizes uncultivated vegetable life or the terrain devoid of animal life or signs thereof. For that matter, aside from the occasional lightbulb, telephone line, gas station, automobile, or railroad track, there's no insistent trace in any of the post-1988 images of what we might call the modern world: not a radio or TV or computer, not a food wrapper bearing a recognizable brand name, not a T-shirt or billboard with a familiar logo or advertising slogan, nary a neon sign, no machines. For all intents and purposes, layers of time have been pared away here as well. Barring a few inevitable anachronisms of clothing and building fabrication, these pictures could have been made a century ago or more. Having visited some of these towns over the years, I know those novel artifacts and signs of civilization exist there, take as deliberate their exclusion from these images, their absence from the world Carter constructs so patiently.

What he suggests by this is that the creatures who interest him most live close to the land, self-sufficiently and accepting their fundamental isolation, in ways largely unchanged over the past several hundred years. All he asks them to do (but this is surely no small thing) is to show him how they live and what defines and enriches their superficially spartan existences. What he offers to them in return is the opportunity to see themselves through his empathetic eyes; what he extends to us is the privilege of, as some folks say, "coming with." The key to enjoying these visits is keeping the eyes and

mind open, observations and acceptance, a willingness to taste the unexpected.

That relishing of adventure will prove necessary because, as the images became more and more off-centered, Carter's embrace of and appetite for the strange—in the world as a whole, in the representative little slice of it he was mining, in other people, and in himself—increased considerably. George Frazier opined some years ago that "An age is great in art and every other way in proportion to the eccentrics who thrive in that time." If that's the case, then (assuming we give credence to Carter's testimony) East Texas now finds itself in a Golden Age, with this photographer as its chronicler and exemplar.

One might say, therefore, that Carter has rapidly evolved into the photographic equivalent of a regional writer, though presently in this country we have so few such writers who achieve prominence—indeed, such a scarcity of well-known regional artists in any medium—that the term lends itself to misunderstanding. Too many mistake the commitment of regionalism for the condition of provincialism, an unfortunate confusion. Jindrich Streit, a Czech photographer still little known outside his native land, has lived and photographed in the same village for going on four decades; one of his monographs on Sovinec he titled *A Village Is the World,* which could serve as the motto for "regional" artists everywhere. Faulkner knew the truth of that, and Edgar Lee Masters, and Marc Chagall, and many others; Carter knows it, too. Once you find the artist in yourself, what you actually need for your art generally lies close at hand. Yet, paradoxically, once you've allowed your central themes and methods to reveal themselves to you, you usually discover them both transportable and omnipresent. Having had some success with his work, Carter now travels more widely than before, photographing wherever he goes. Some of the most recent pictures in this book, previously unpublished, he made in places far from East Texas—Ireland, for example; yet they fit easily in with the rest, suggesting that, for him, the entire world has slowly begun turning into Keith Carter country, becoming home.

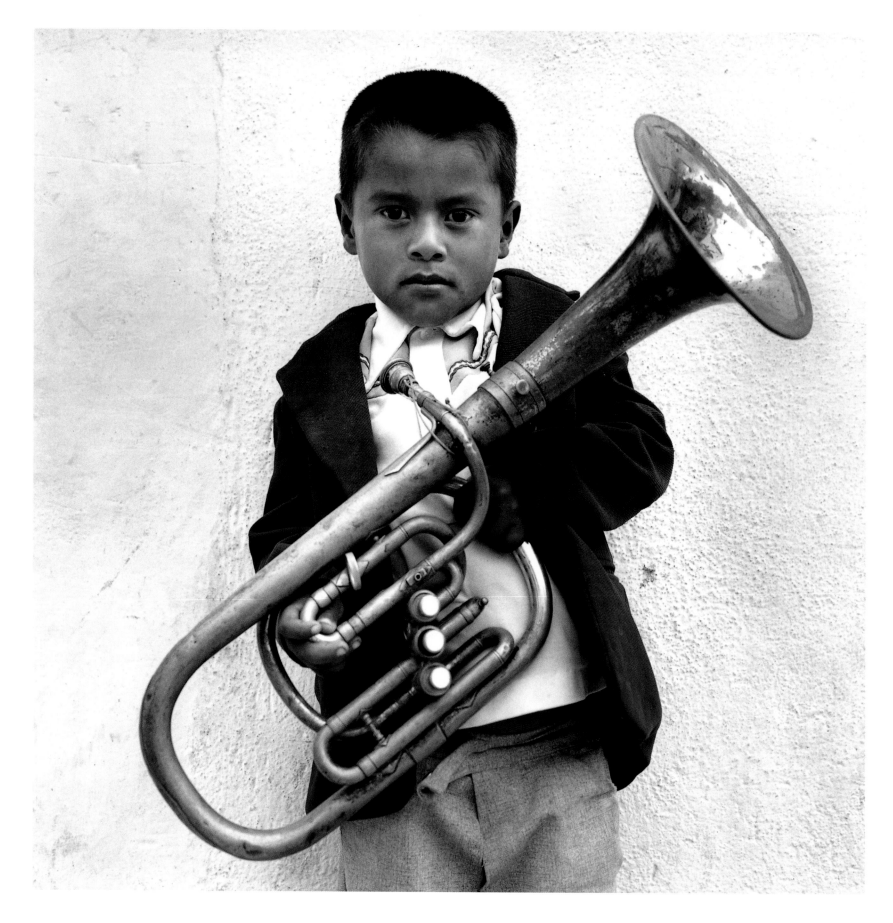

And, though he continues to use strictly photographic means for his work and to define himself unequivocally as a photographer, Keith Carter, before your very eyes in the pages of this book, turns also; turns from an accomplished documentary photographer into an artist, by which I mean to indicate that he comes unequivocally to define his concerns as those of the poet, and uses the medium of photography to address those concerns. As such, though he may eventually manifest epic tendencies, he now functions as a lyric poet, a dowsing rod for that "imagination in the boondocks" of which he spoke and a wellspring of it himself. Patiently generating a quiet poetry of solitude and survival, he reveals to us that ritual, magic, and invention live everywhere that people call home, and that, simultaneously, we remain not that different from what we once were, ever inclined to jump into the mud and piss naked in the swamp, still one form of animal among others. The human apple, he proposes, does not fall far from the species' tree.

If I were to compare Carter's images directly to poems, I would suggest that we might think of them as sonnets. In its structure the sonnet contains a definite formality, a weight and density, a sense of containment, a demand for resolution. Less flexible than more open forms of verse, it resembles in its symmetry the square, that elementary geometric shape Carter favors as the cutting edge for his vision. Many poets find sonnet form constraining; for some it proves so much so that they chafe at its restrictions and abandon it for more loosely defined modes. But some embrace its strictures, settle into them, and begin to explore what they allow. And, of those, some few discover there, in the words of one of its most devoted servants, "not chains but wings." If, of all the pleasures this survey monograph affords us, the one most generously and deliberately offered is its open invitation into a peculiar and magical parallel universe, then the deepest intimacy in which it involves us is that of watching Keith Carter learn to fly.

Staten Island, New York, October 1996

F

U N C E

T O

B L U

R O M

R T A I N

E

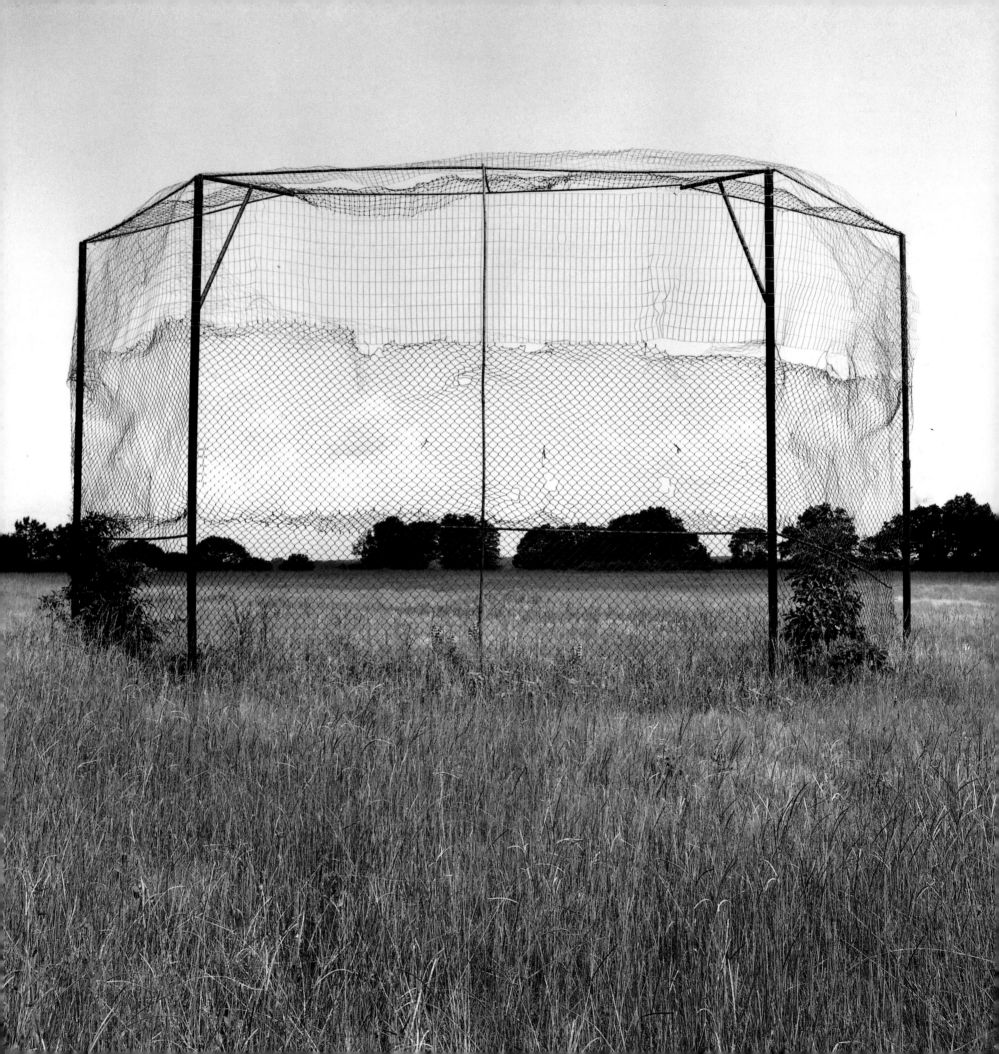

NOONDAY 1987

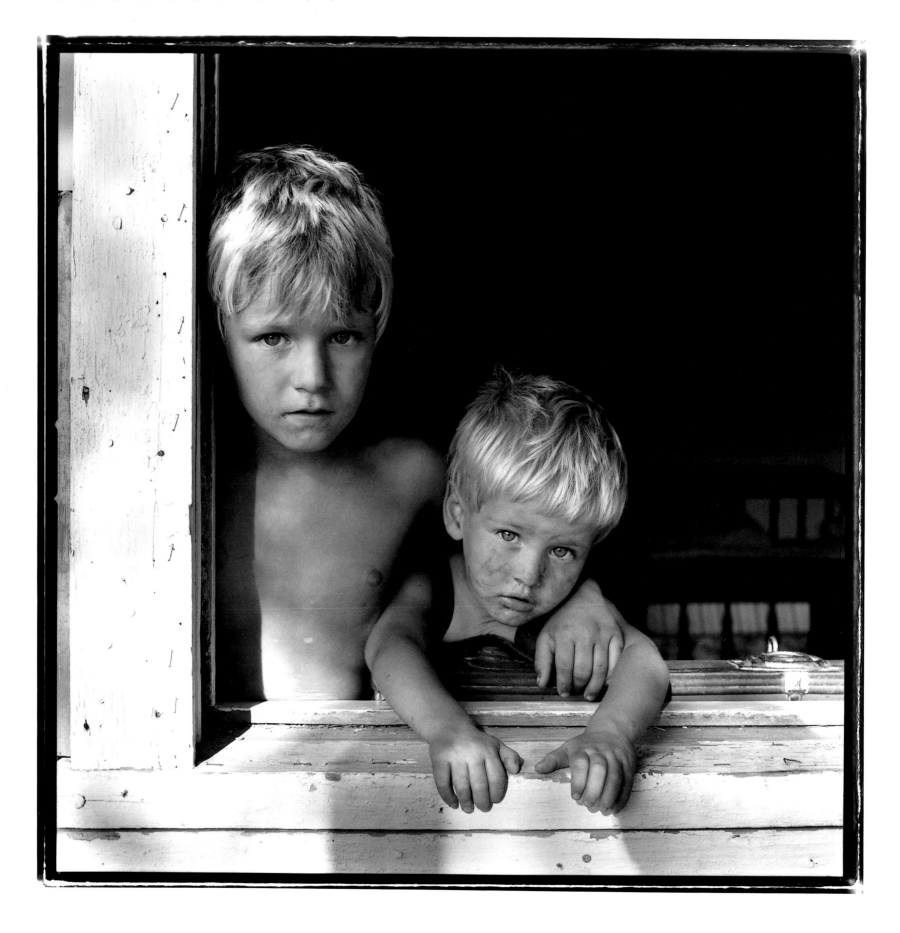

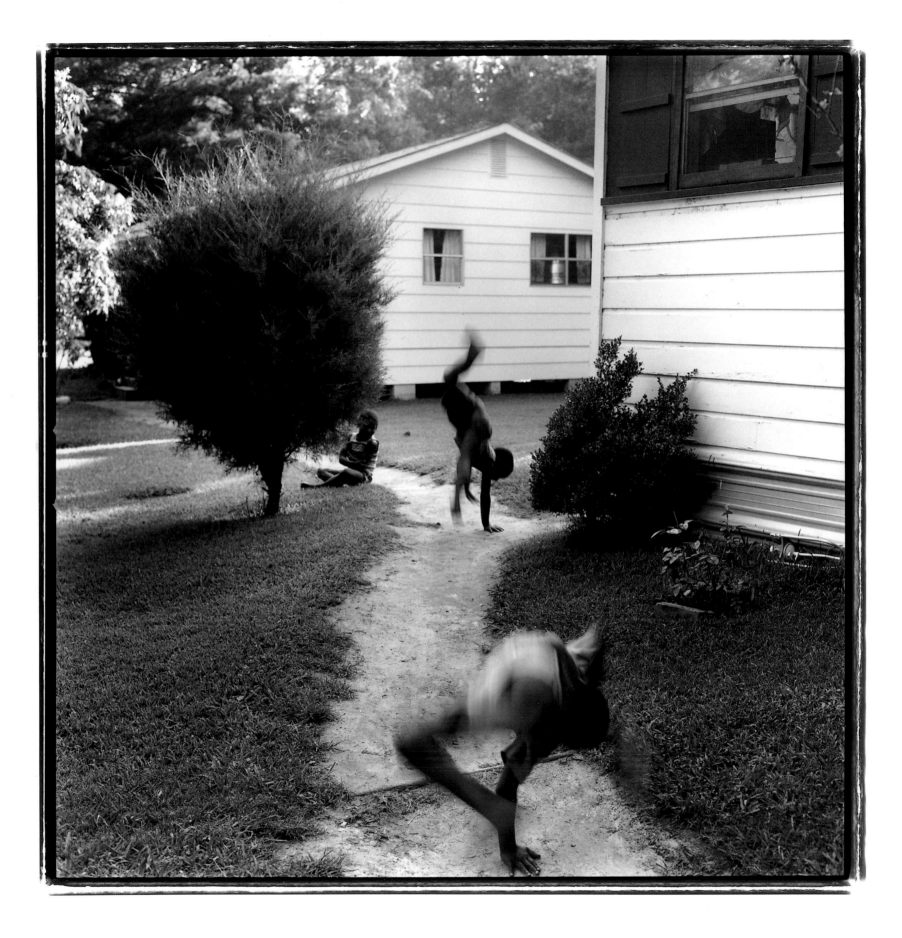

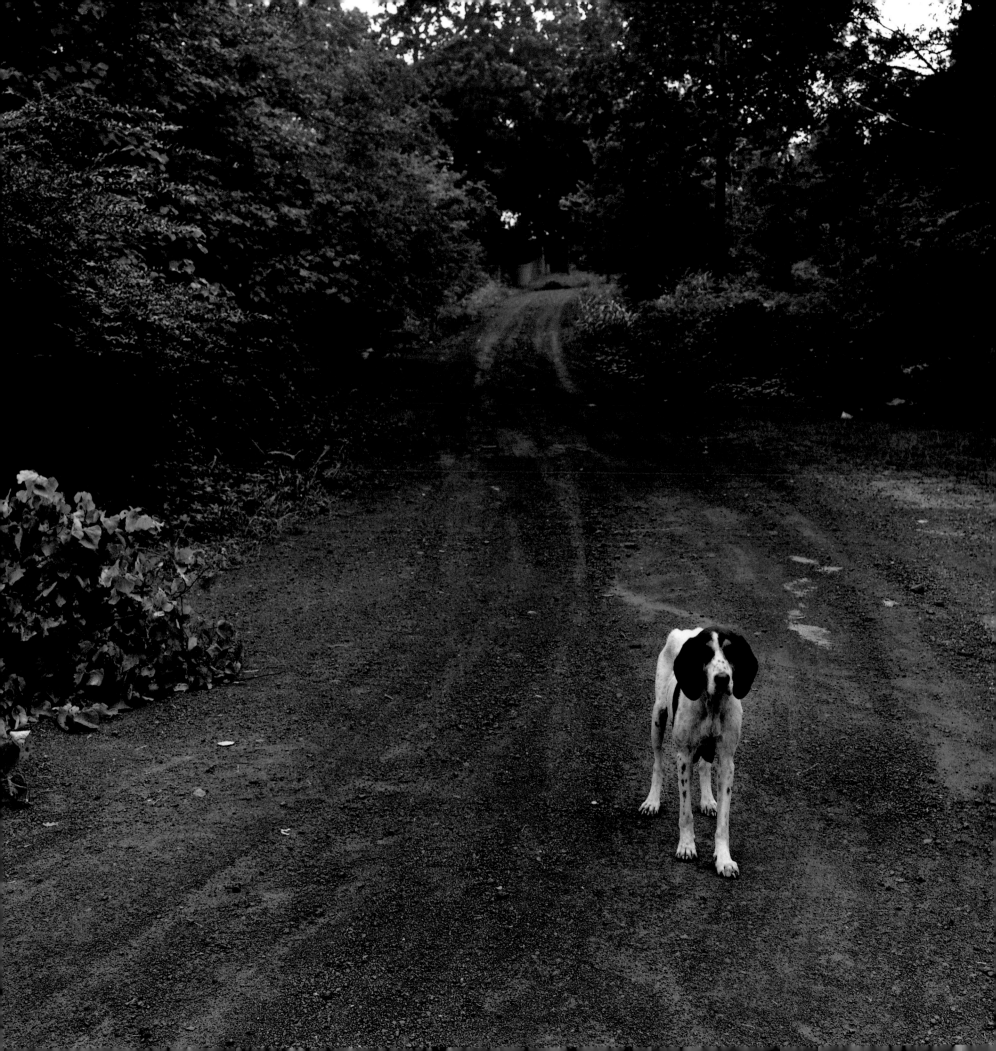

THE
B
T M A

L U E

N

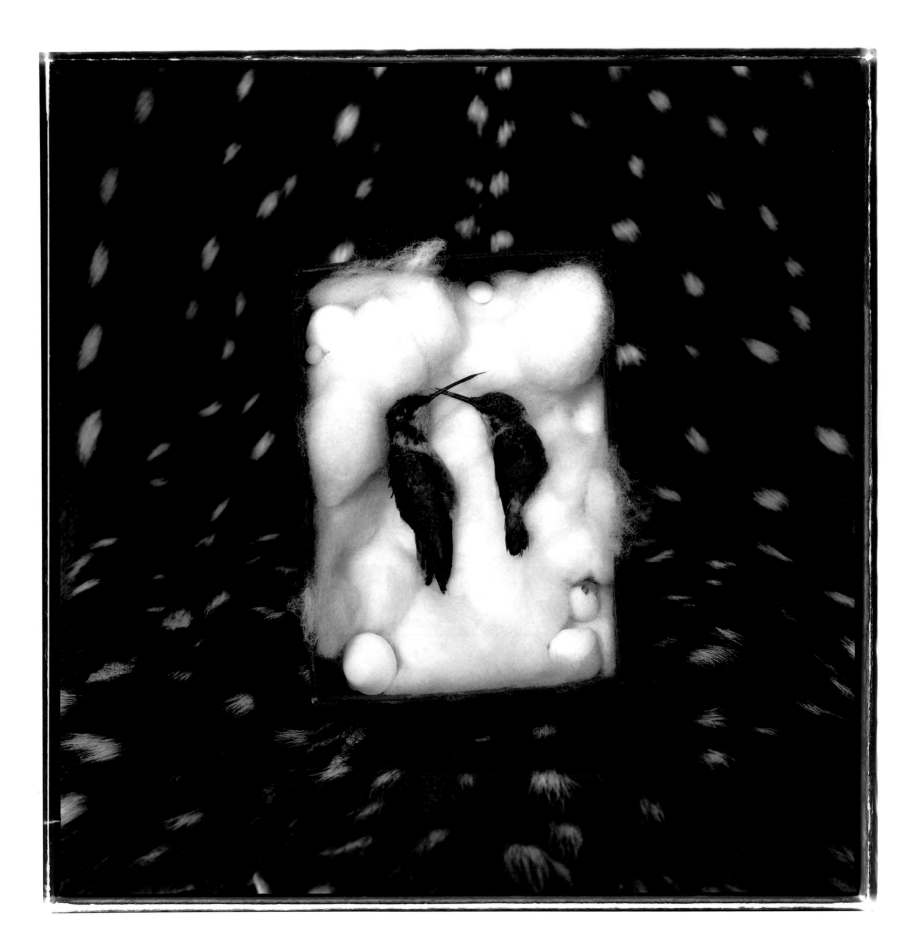

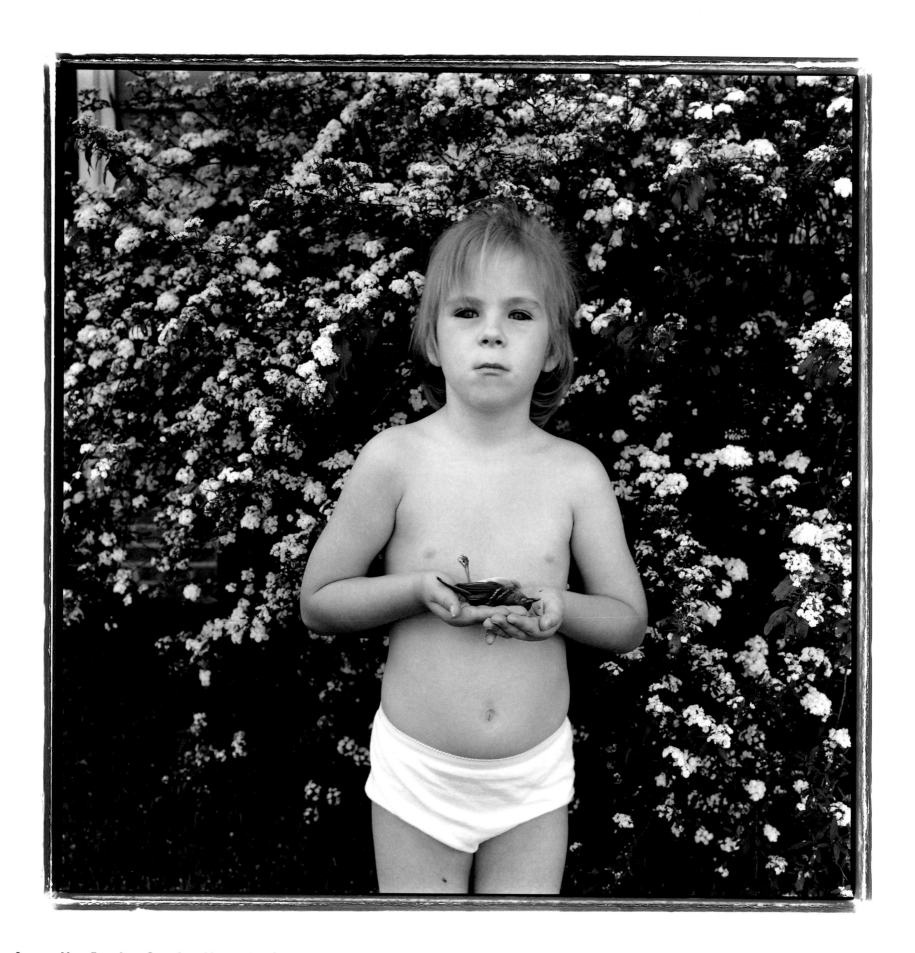

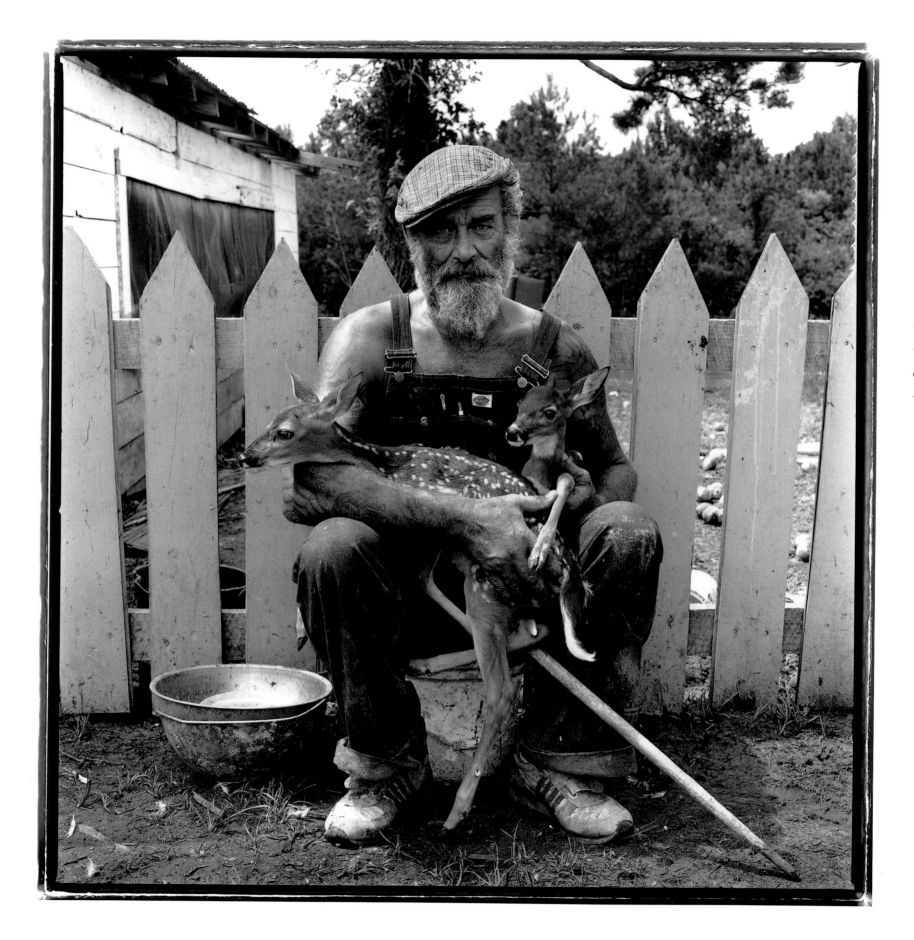

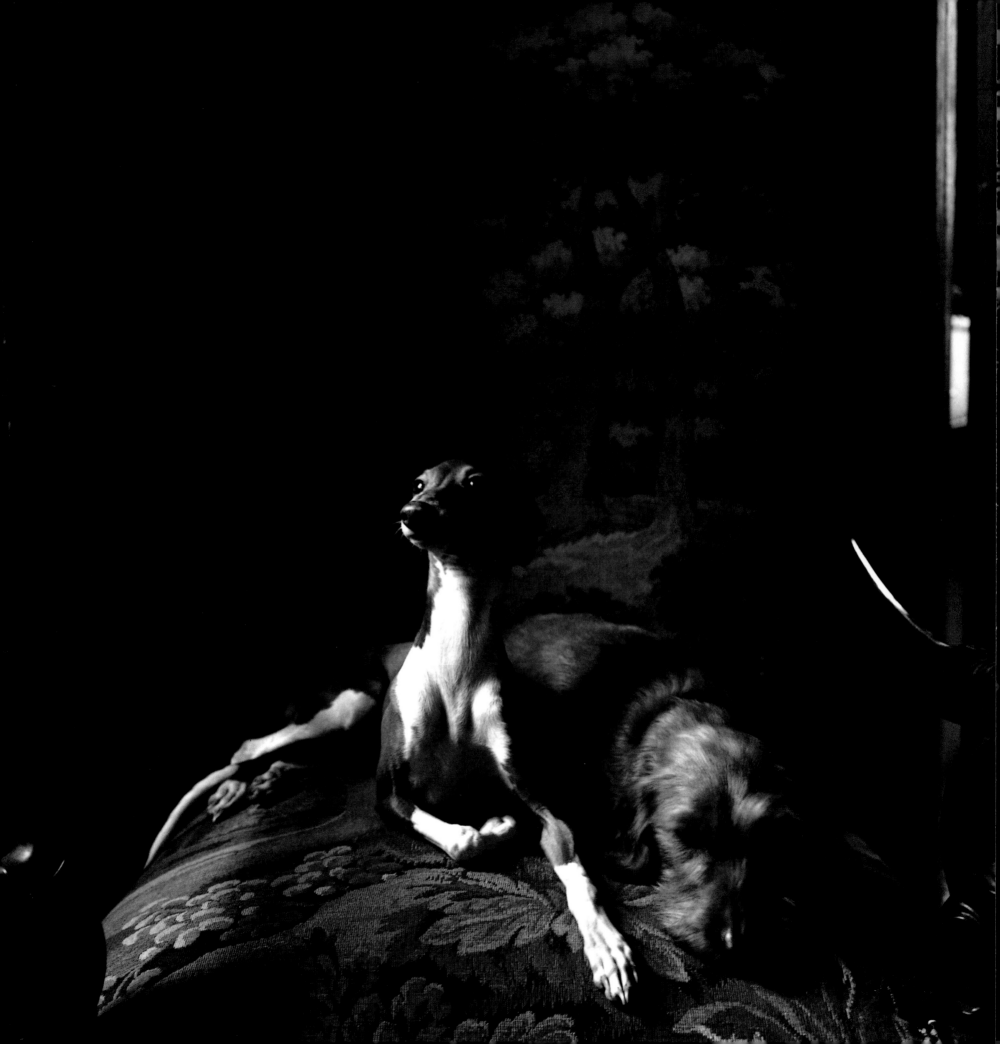

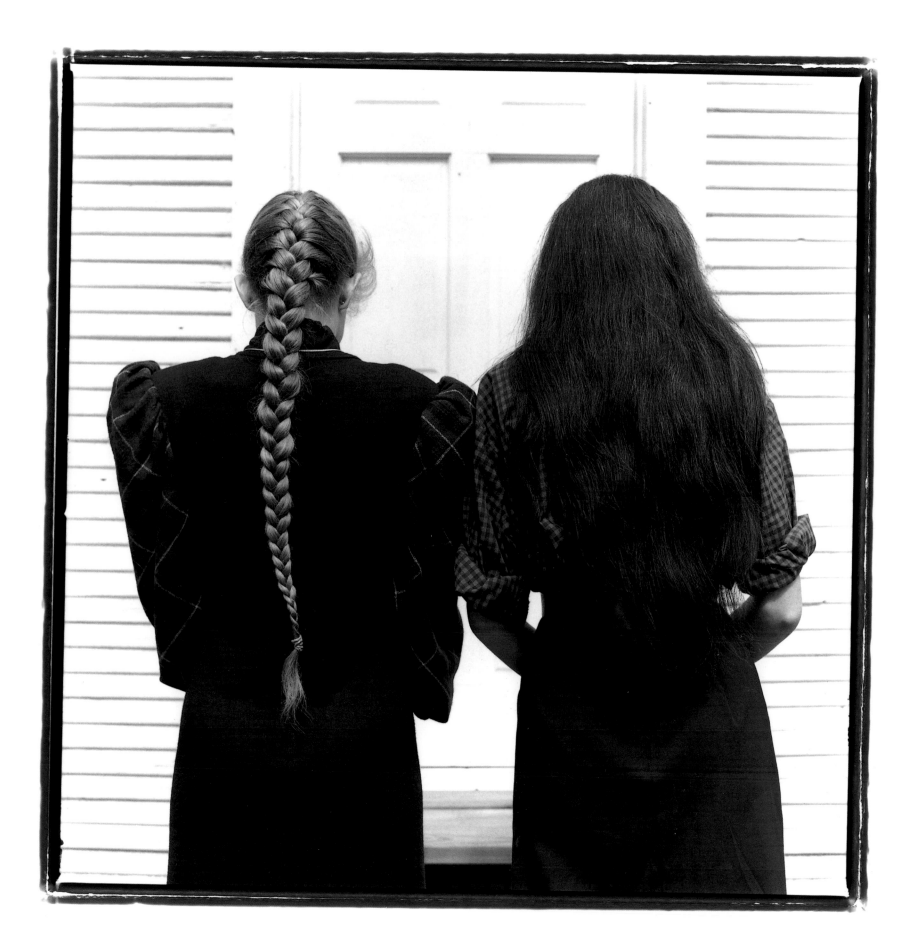

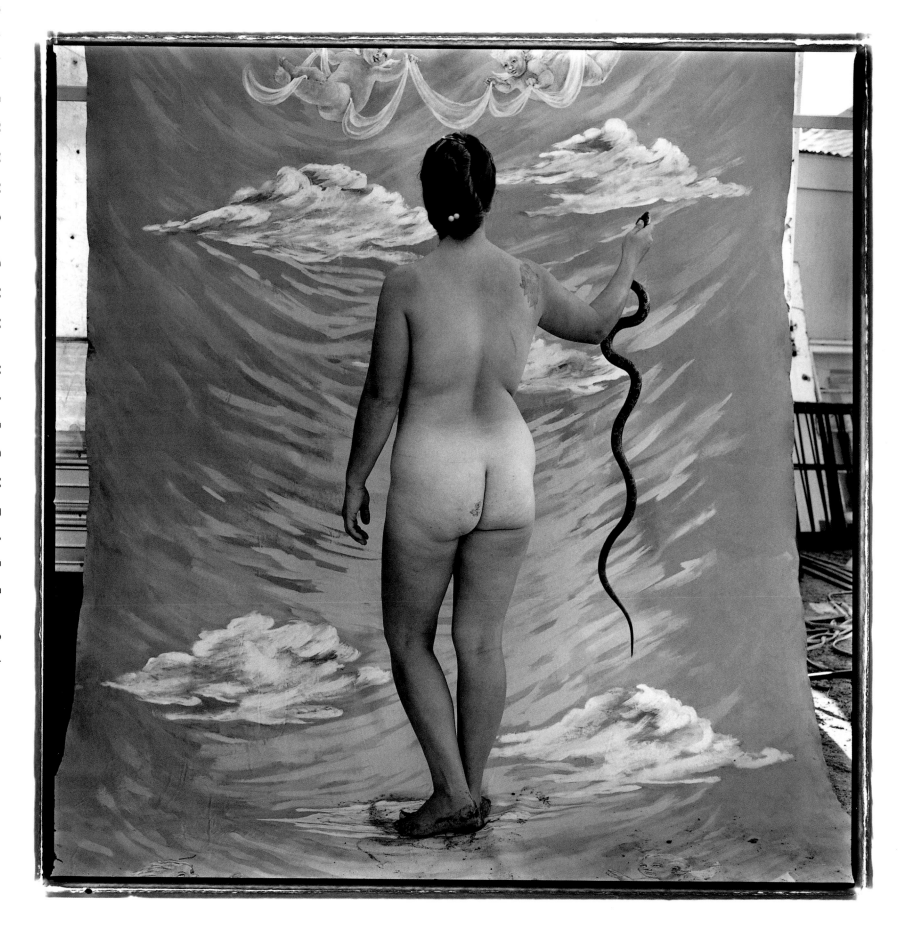

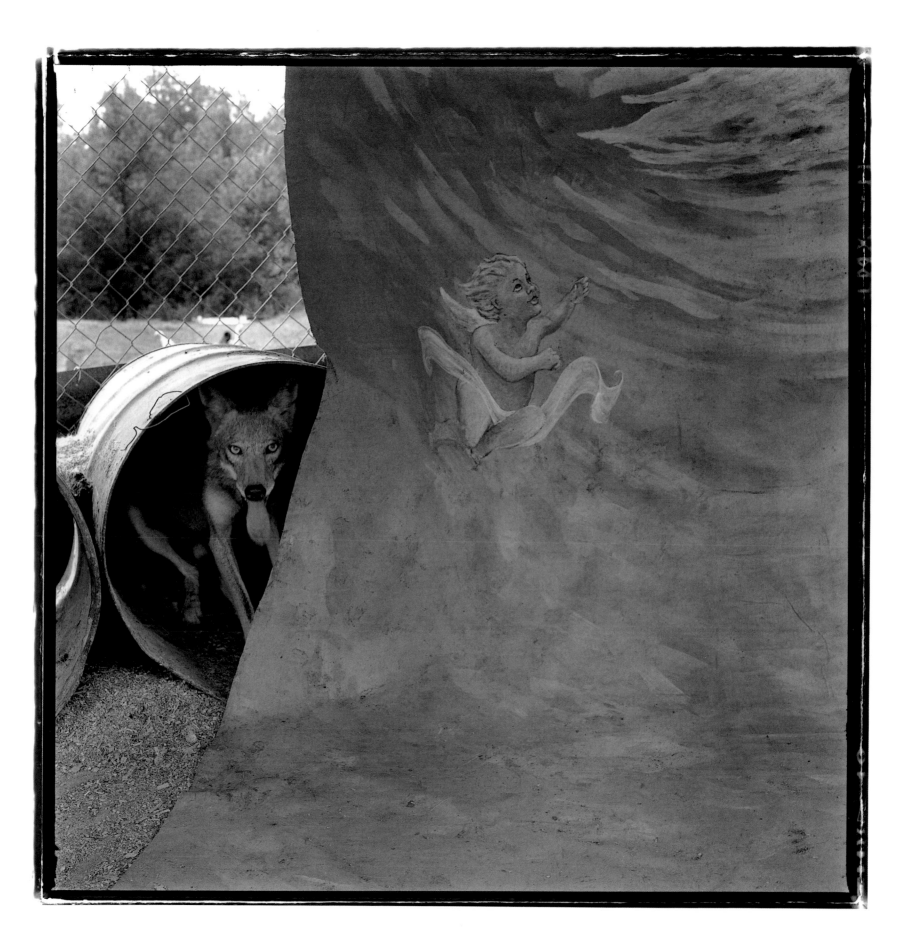

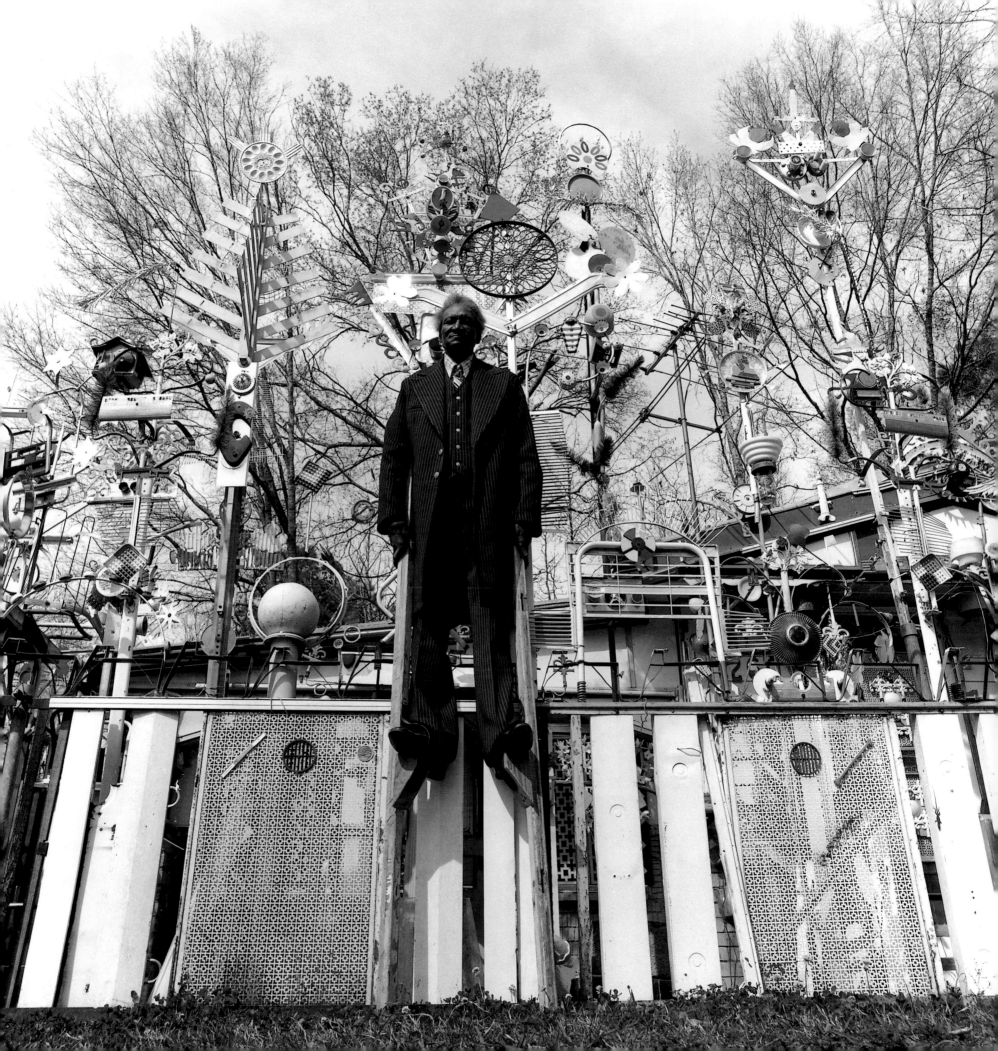

OJO

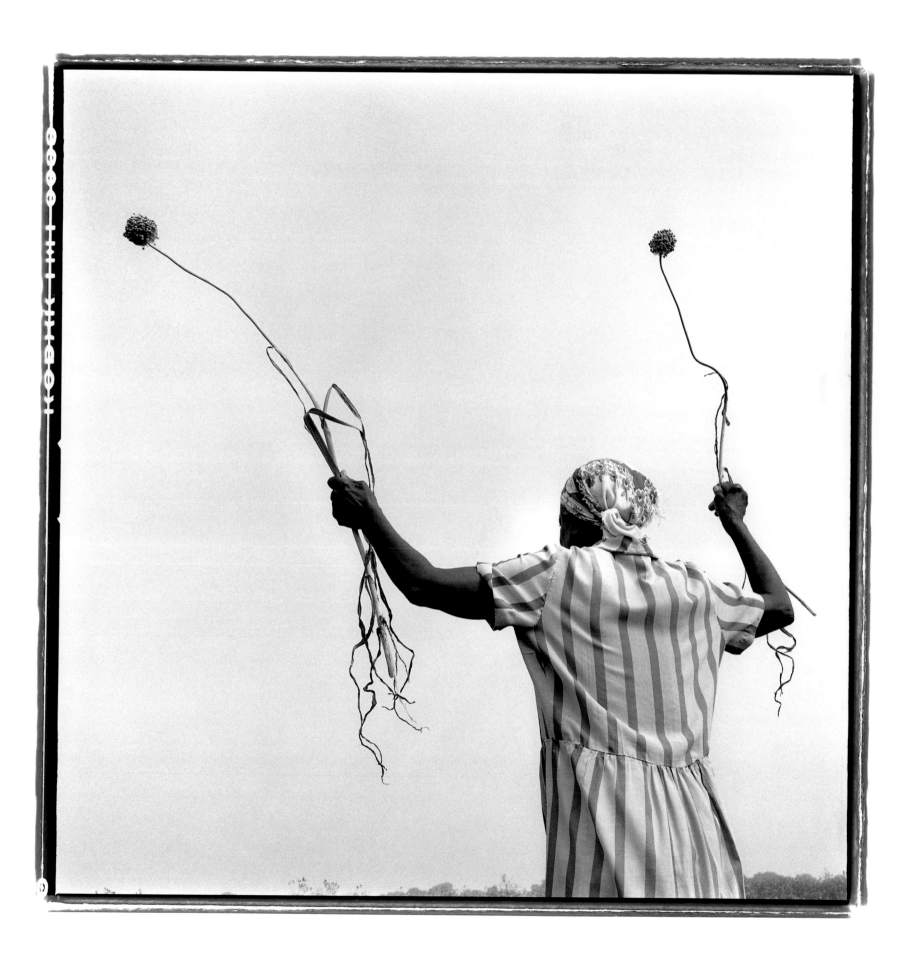

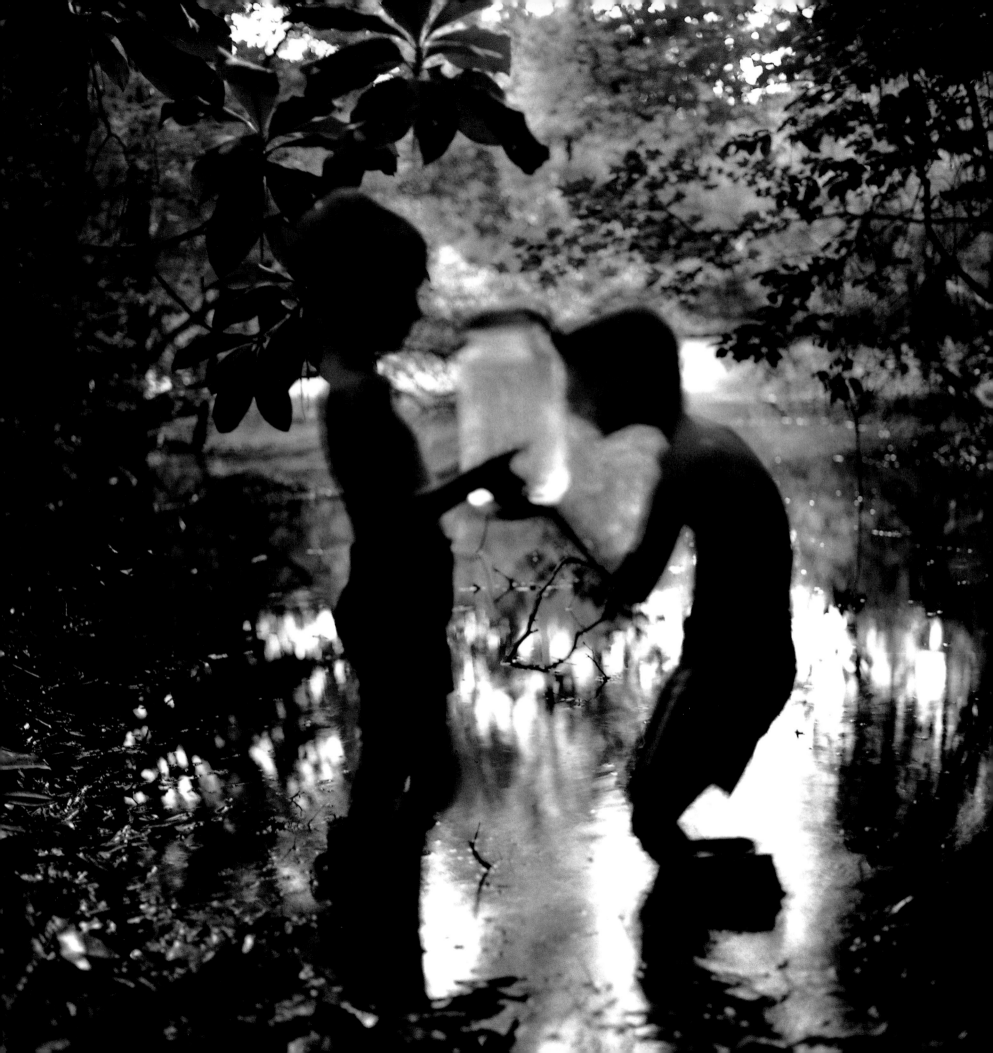

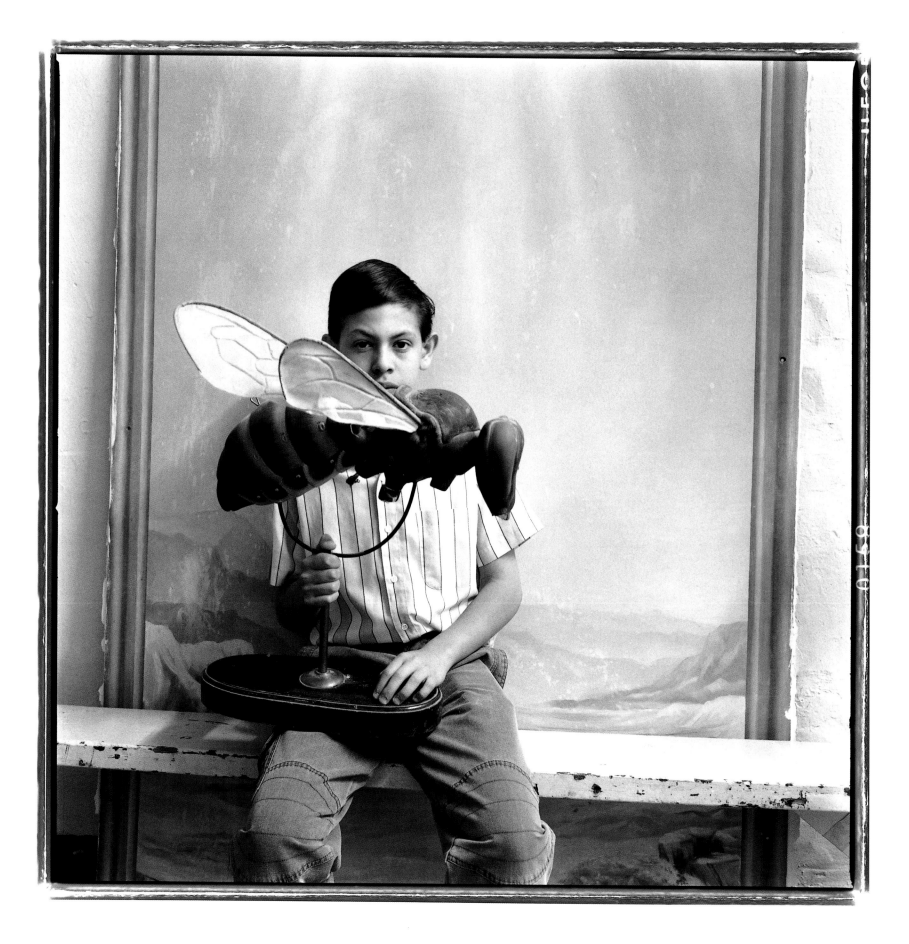

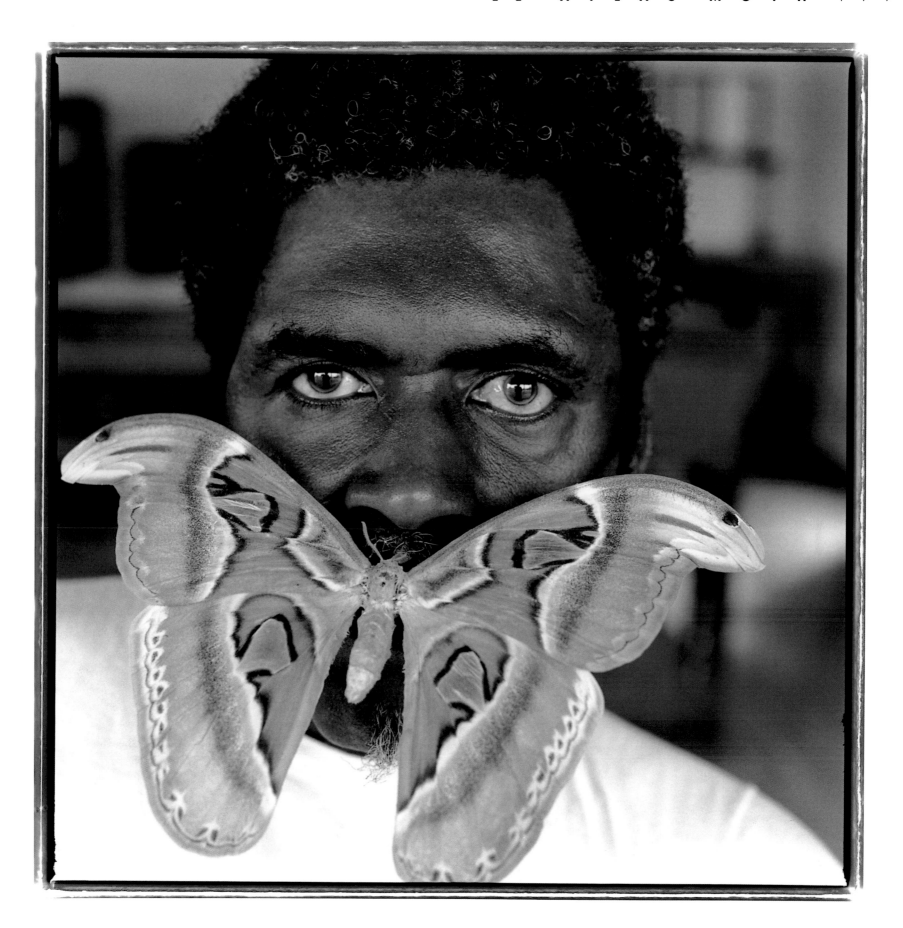

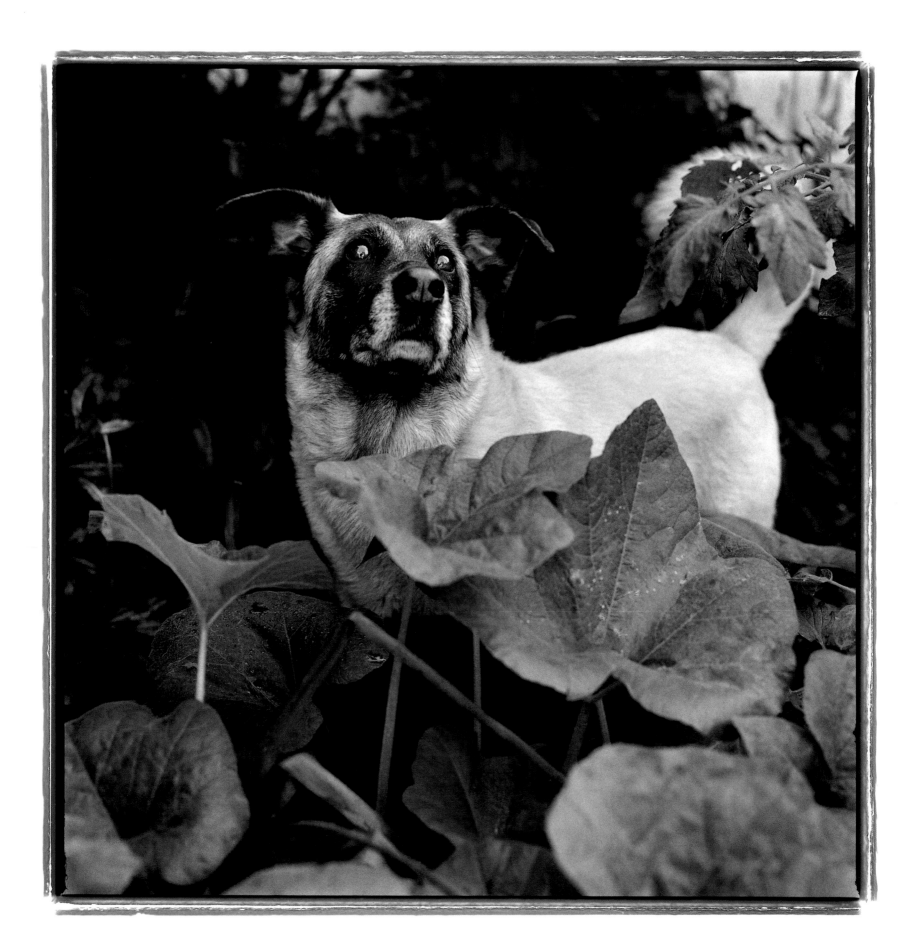

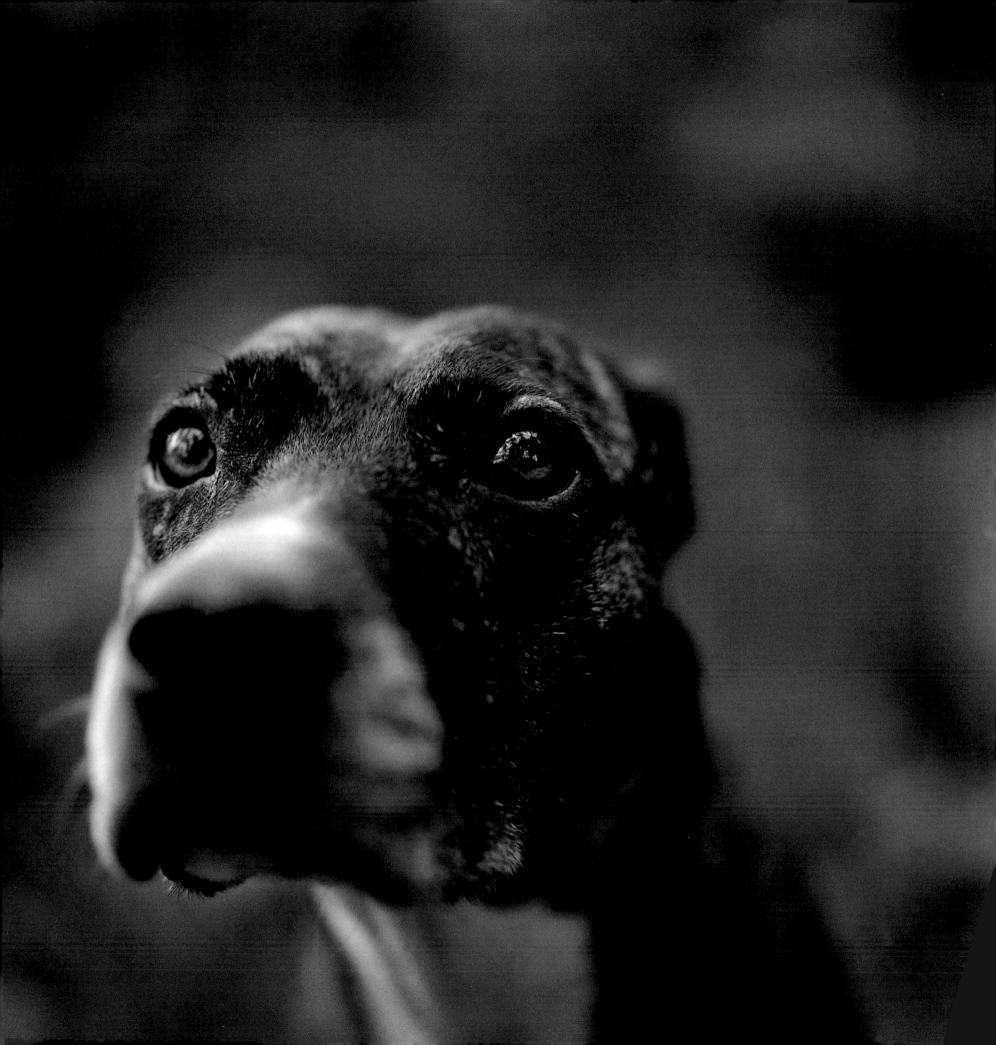

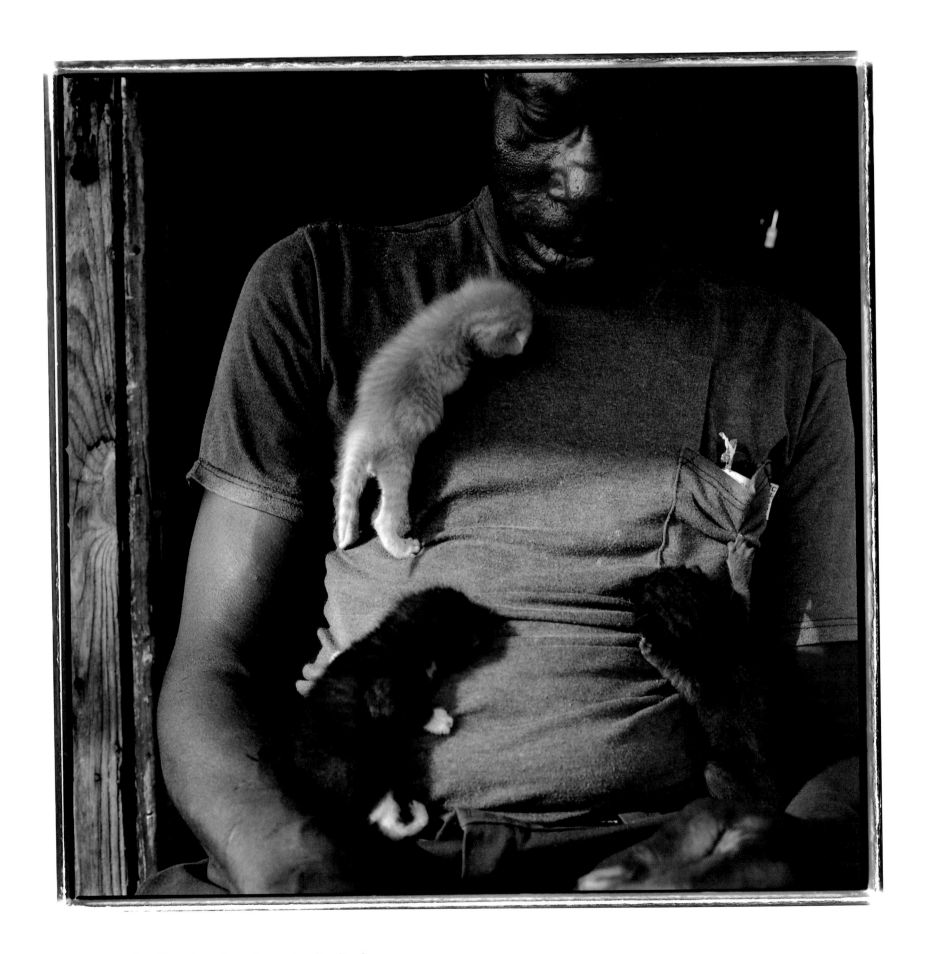

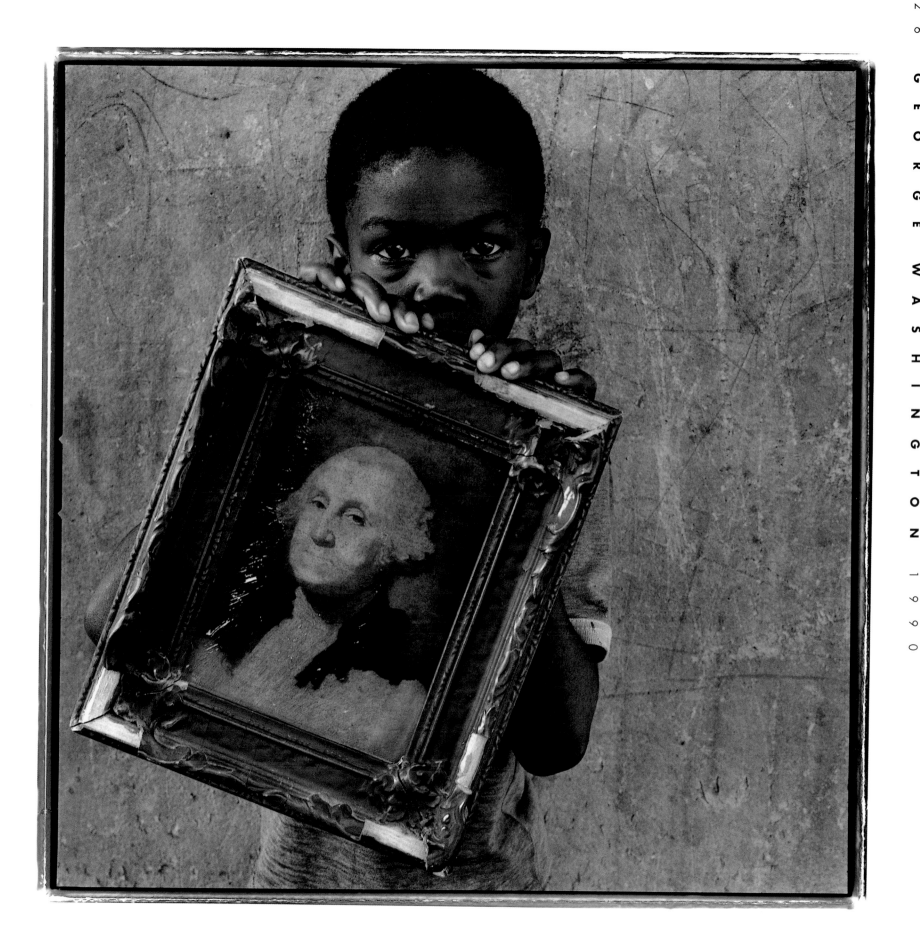

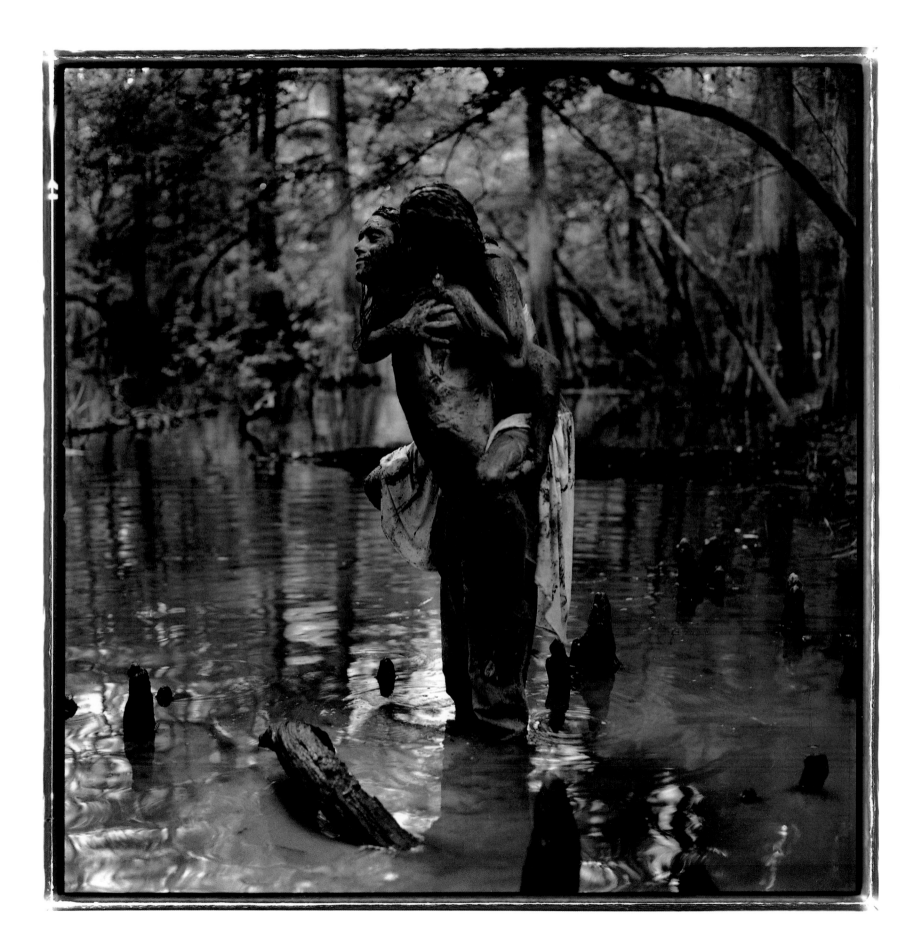

HEAV
OF
AN

E N

I M A L S

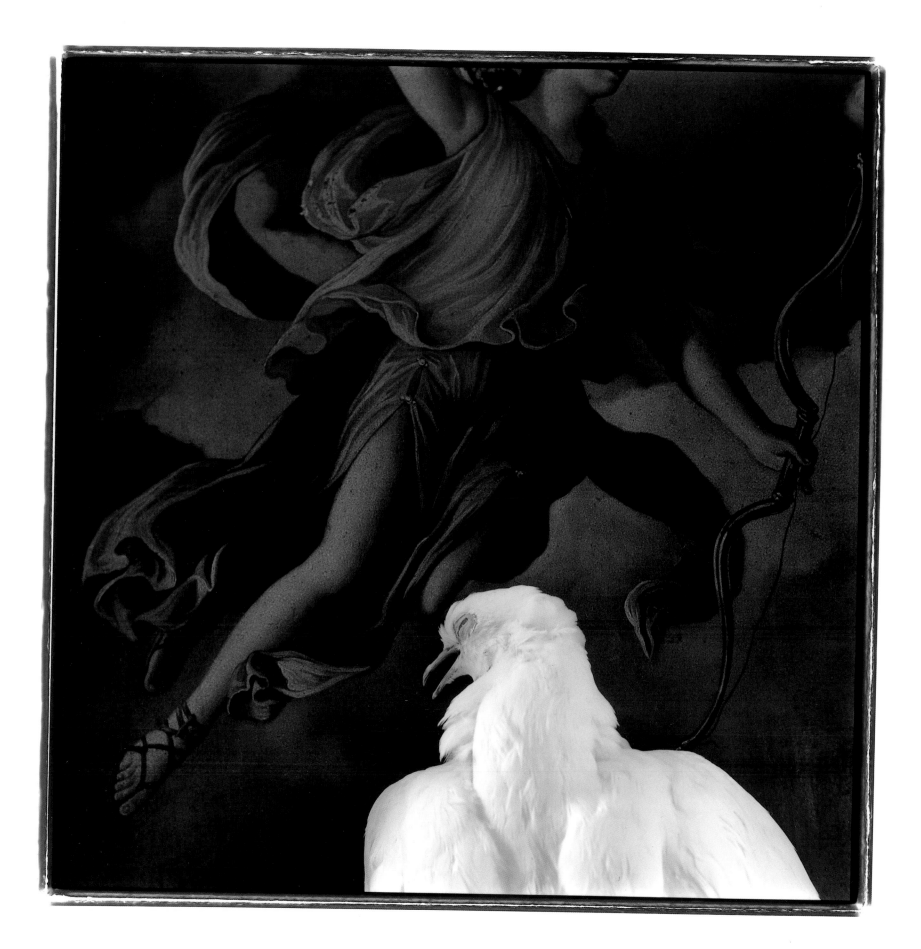

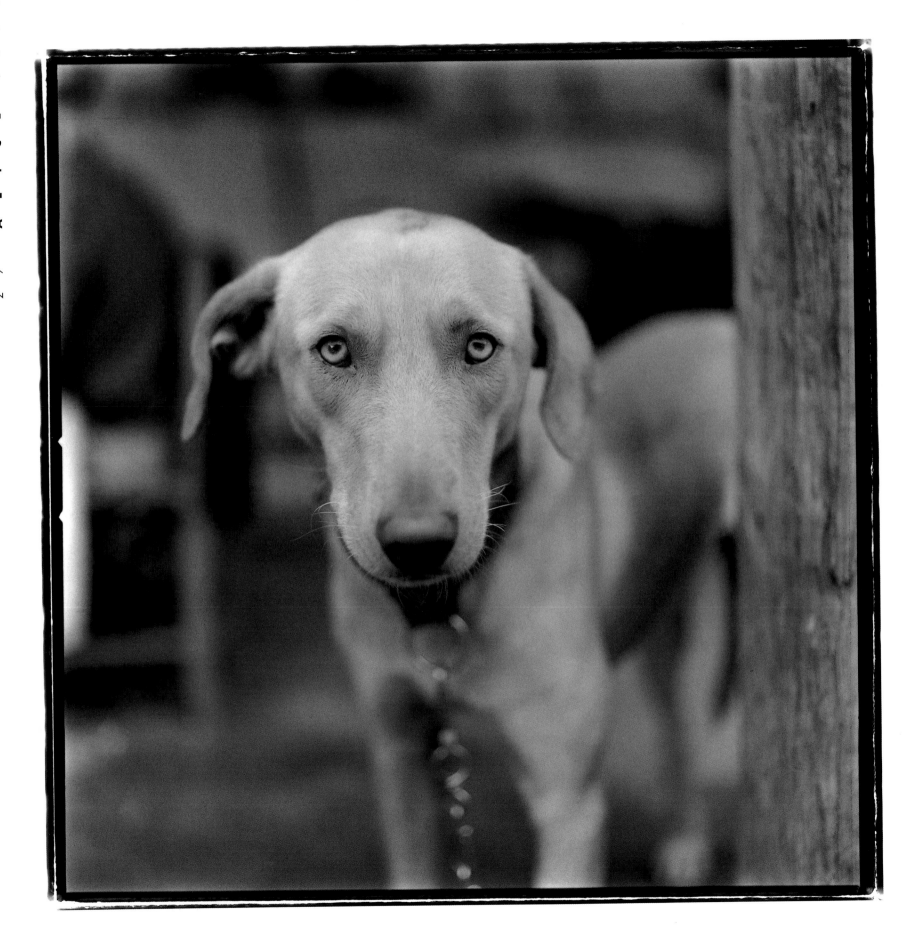

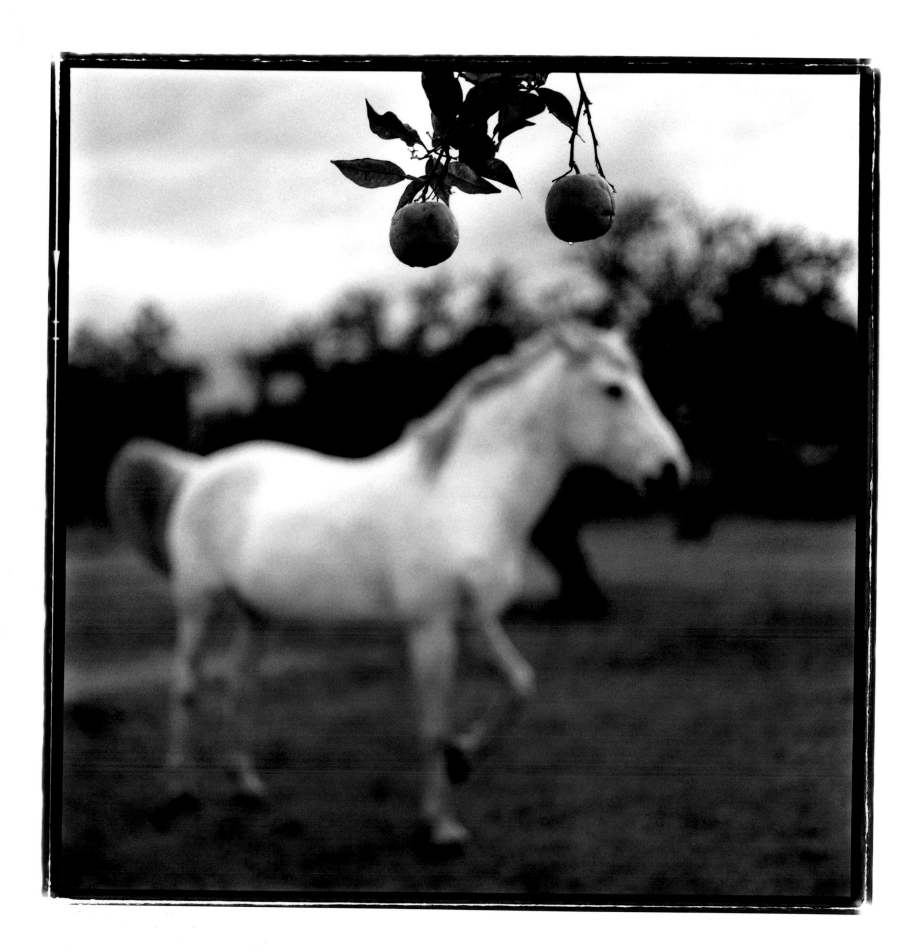

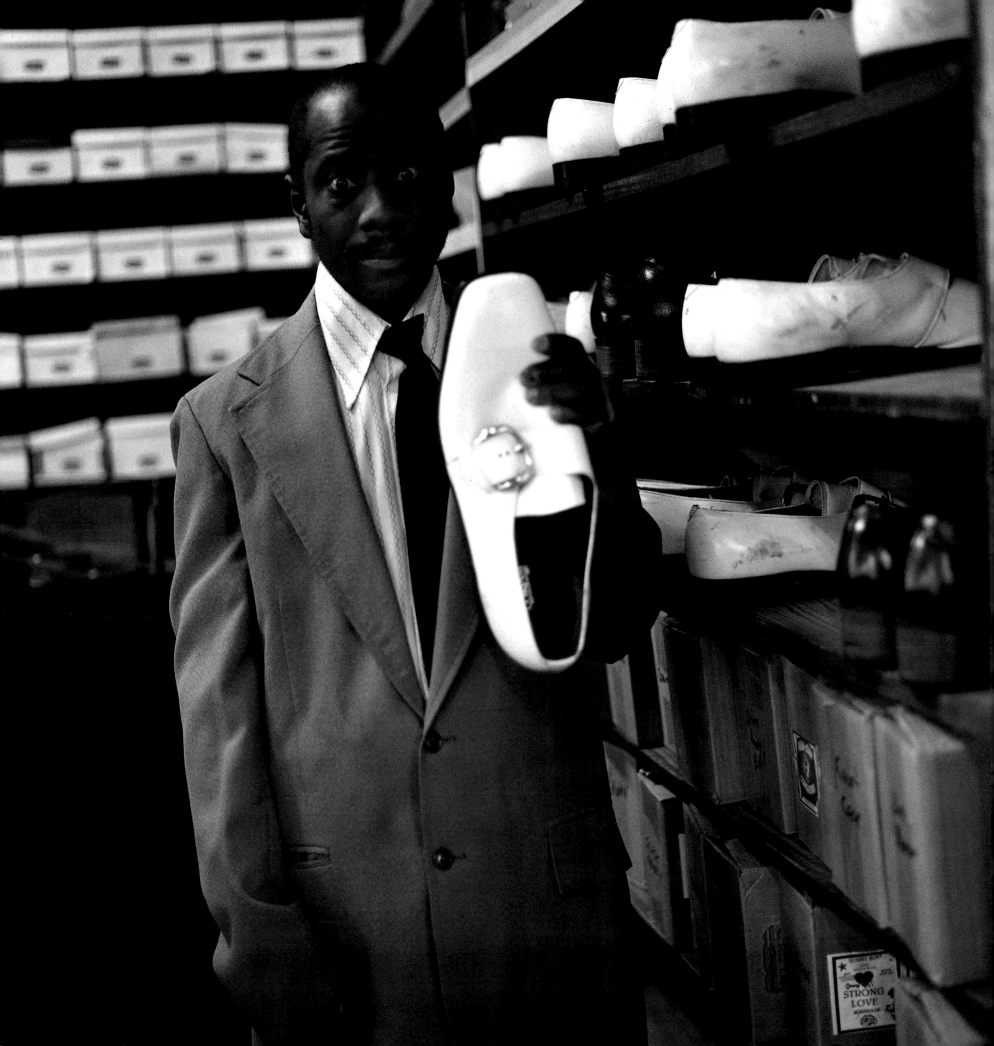

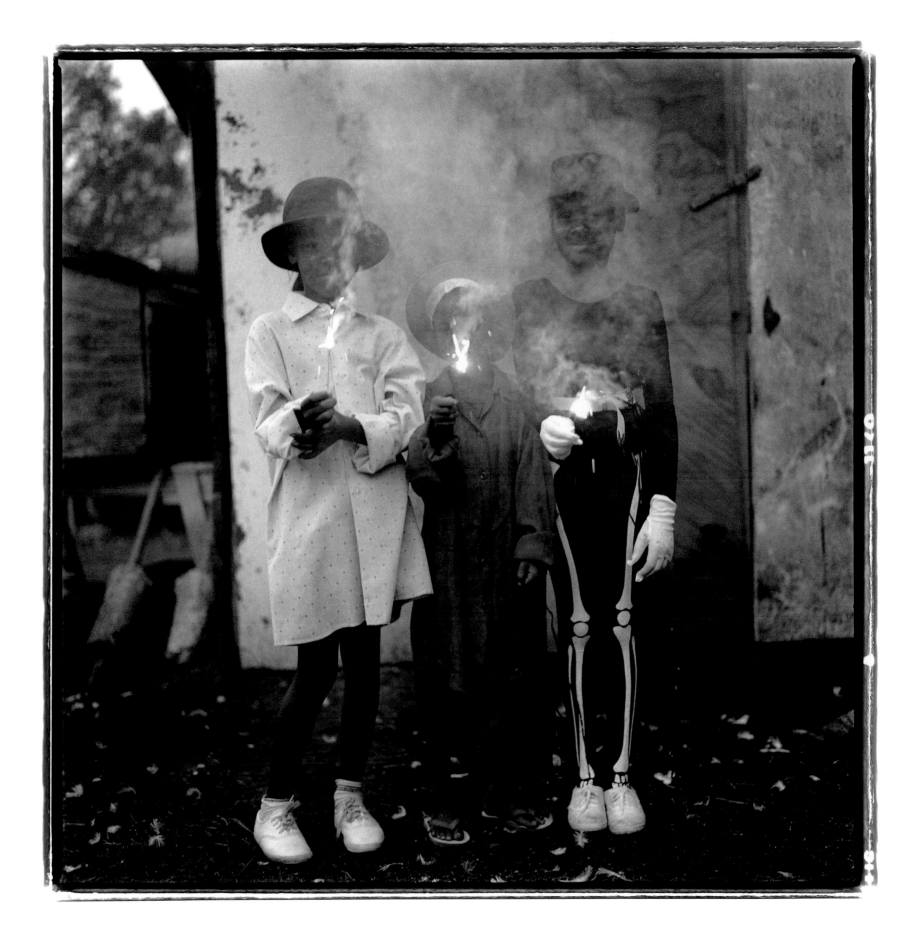

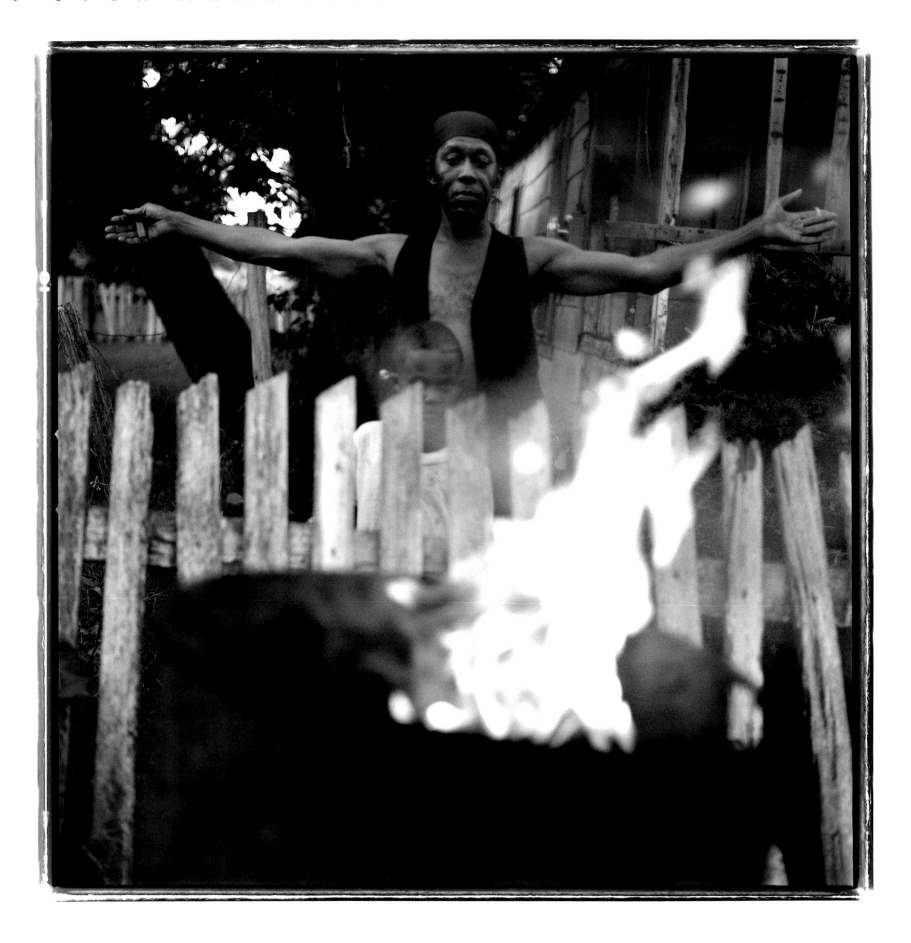

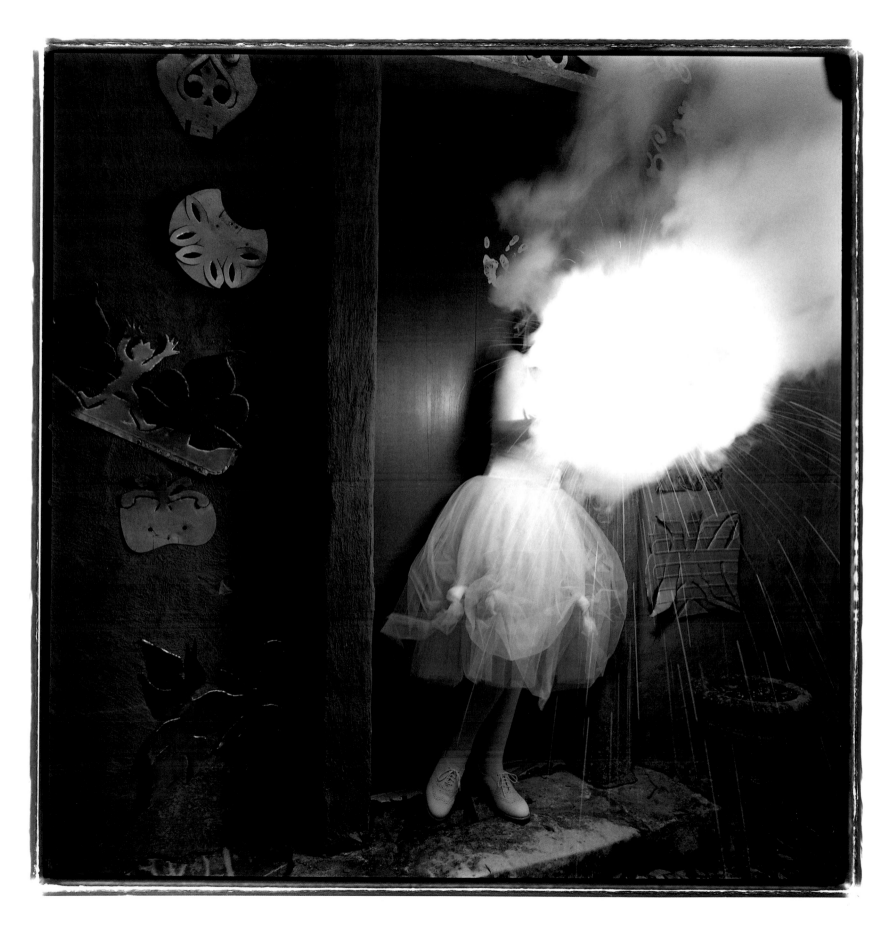

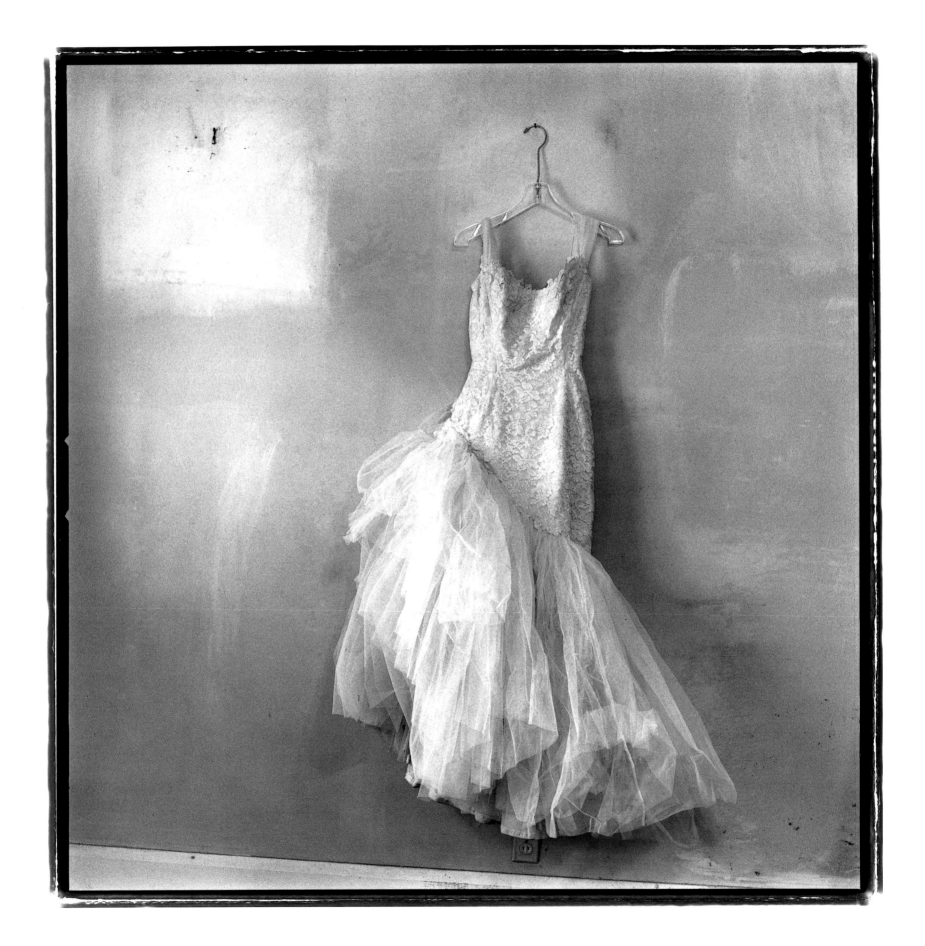

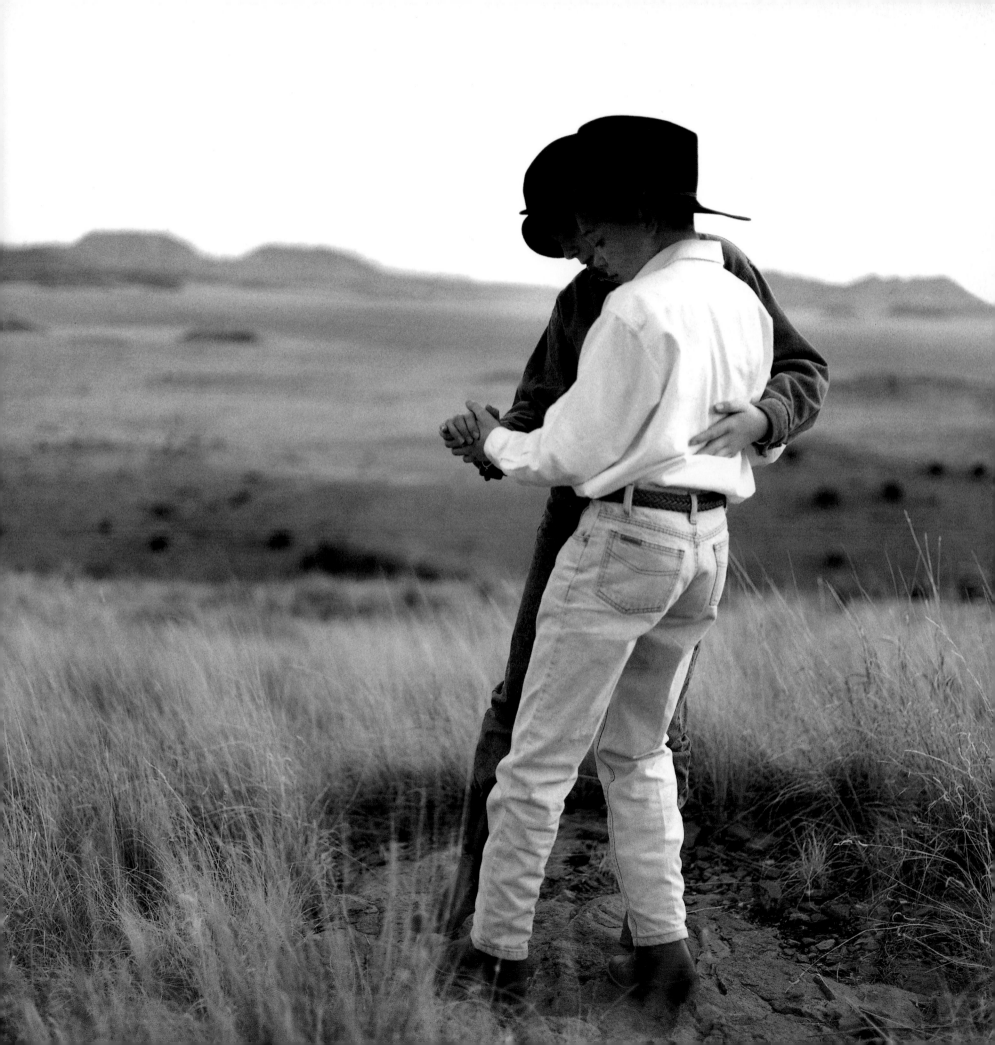

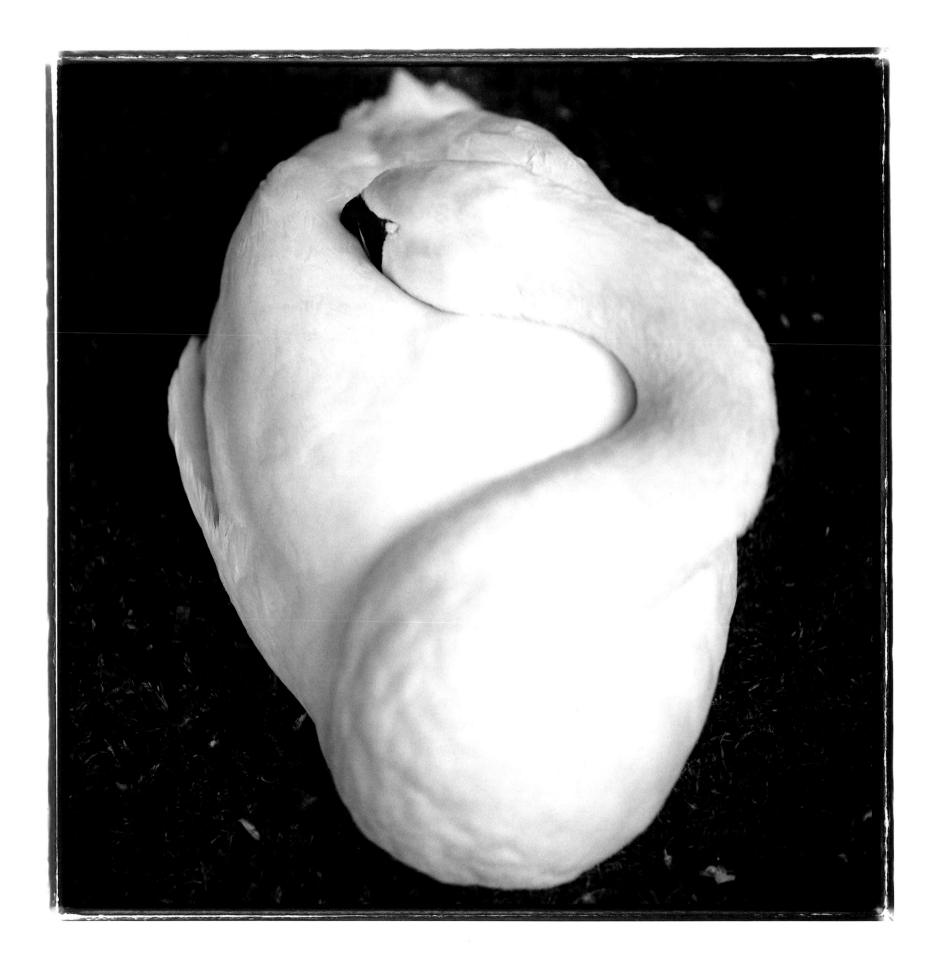

B O N

E S

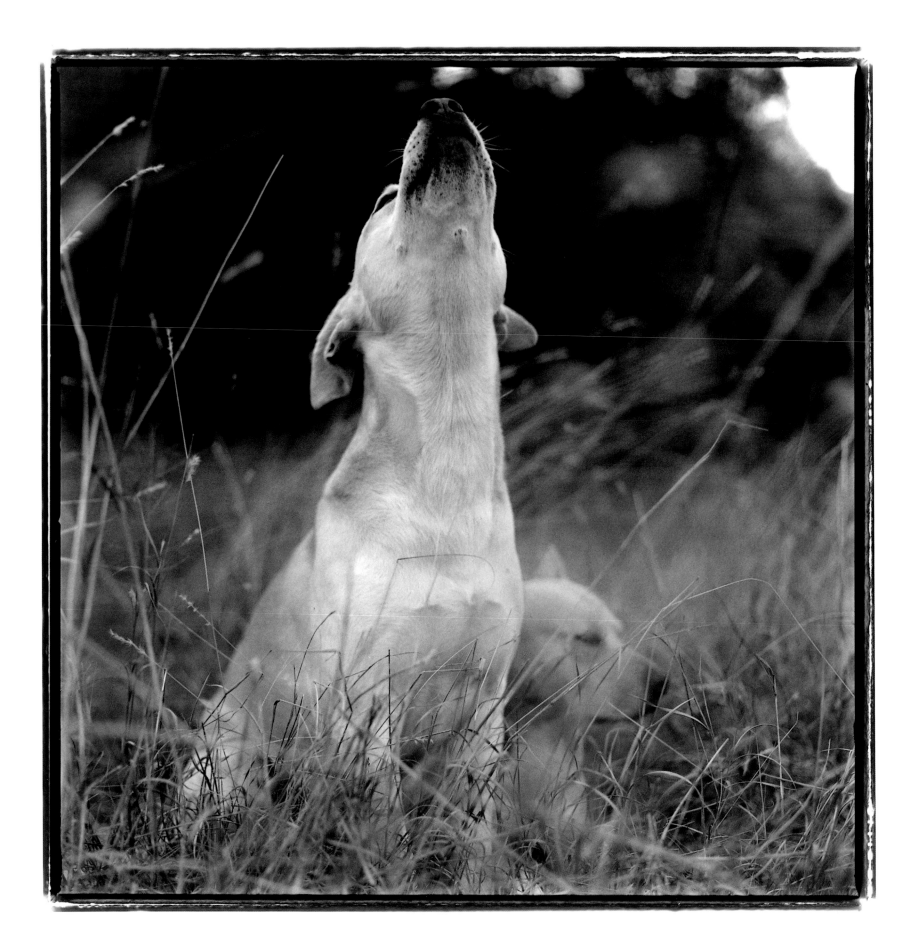

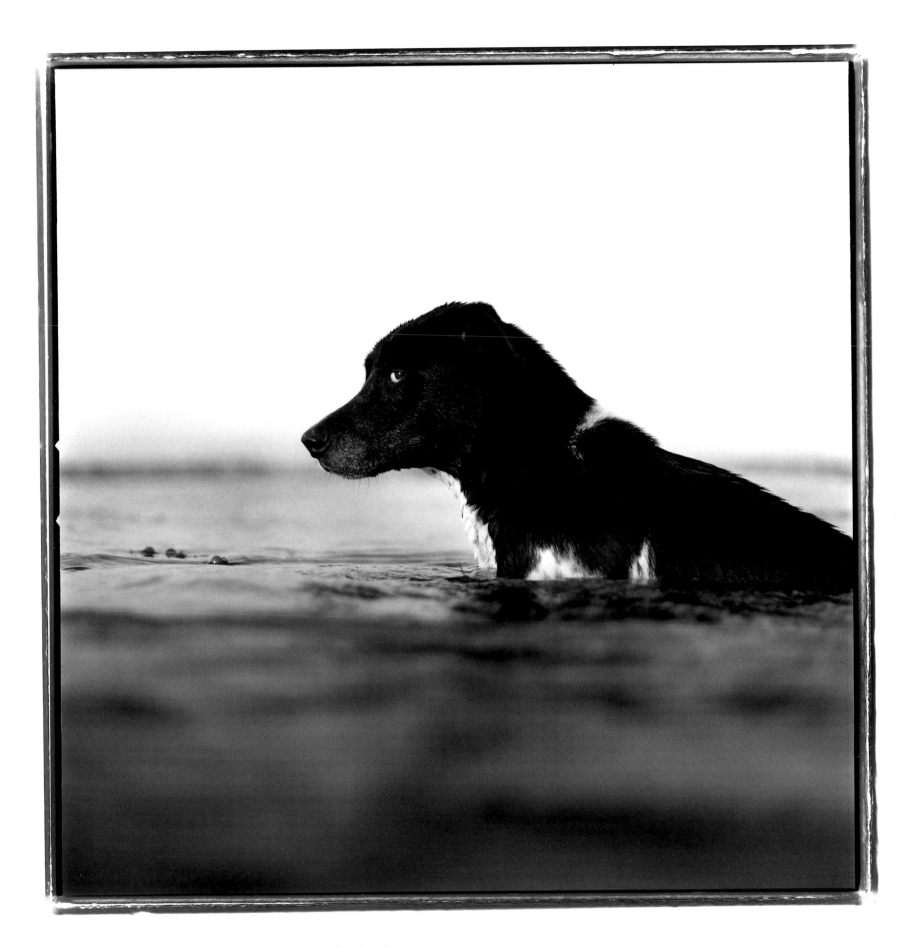

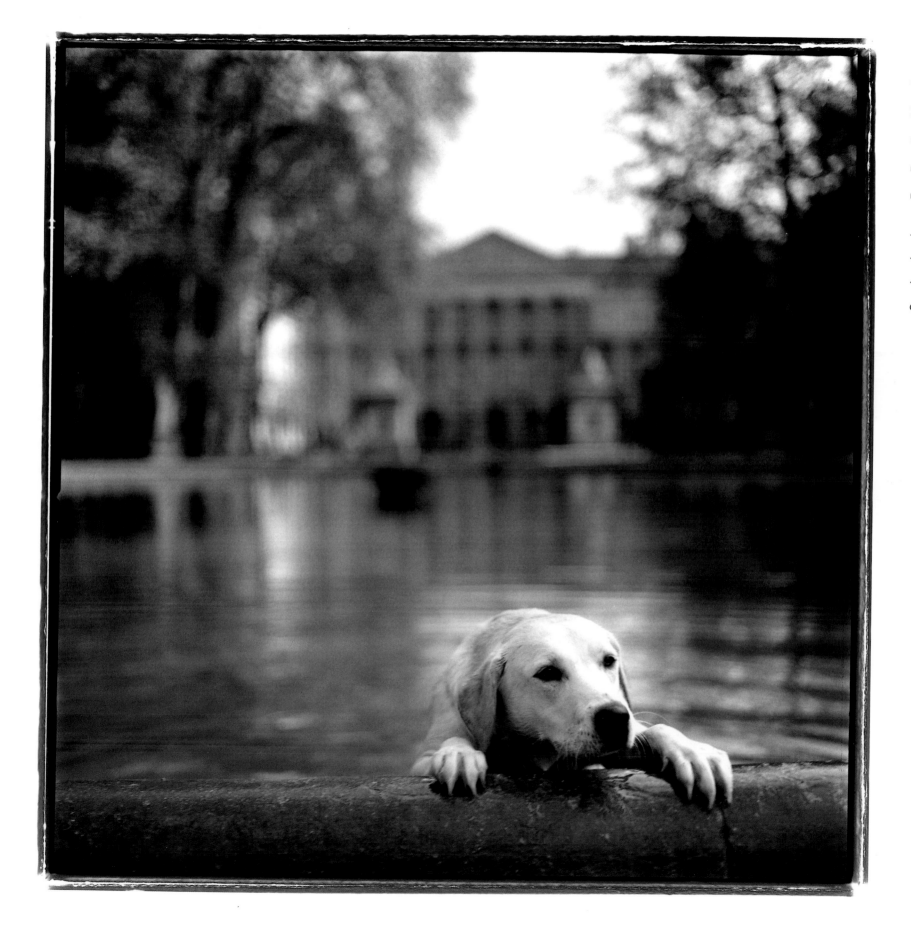

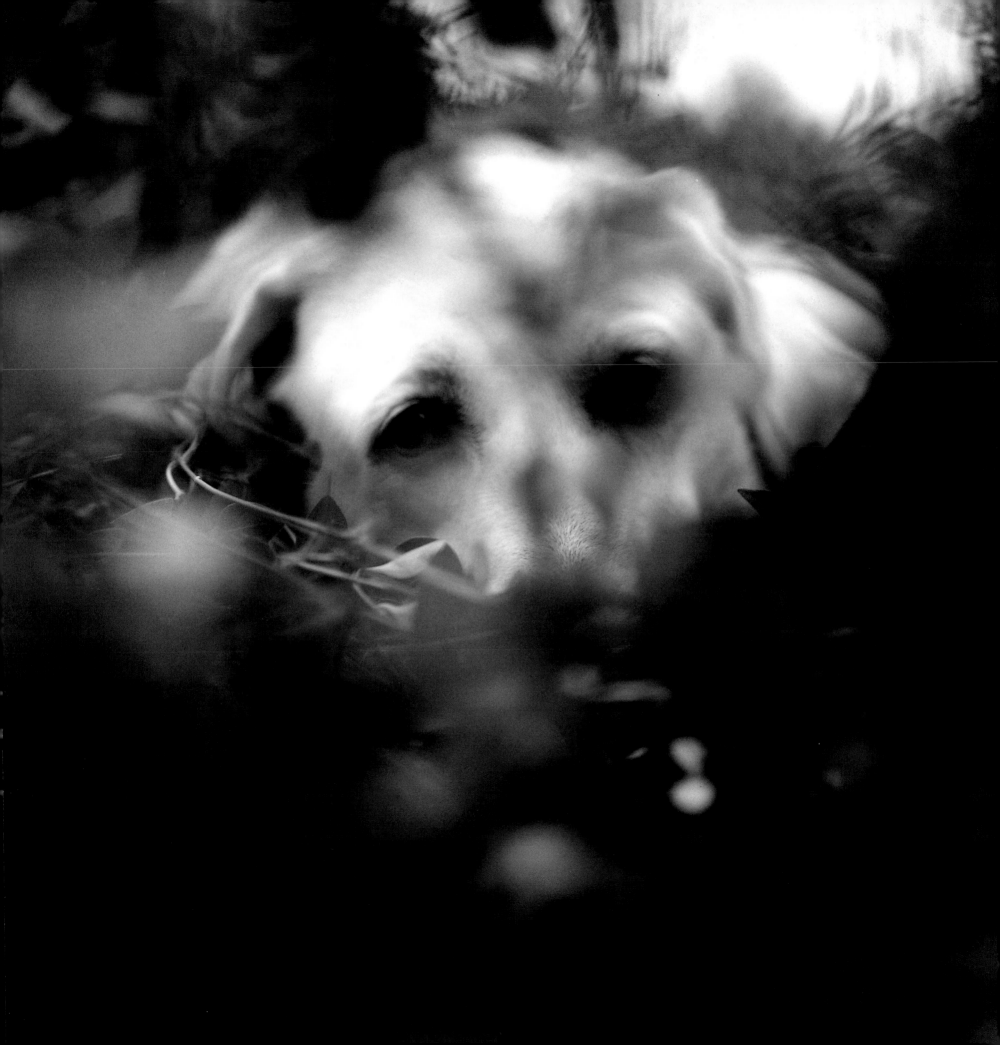

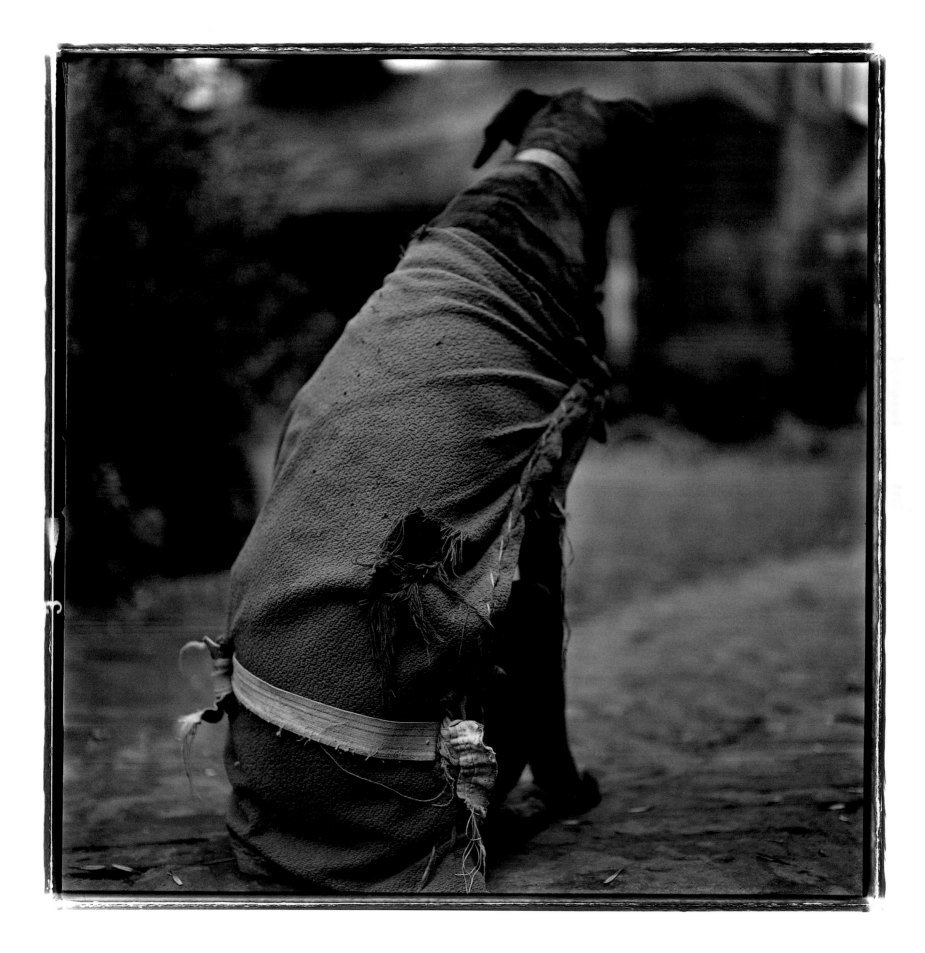

W O R K

1 9

NEW

95–

1997

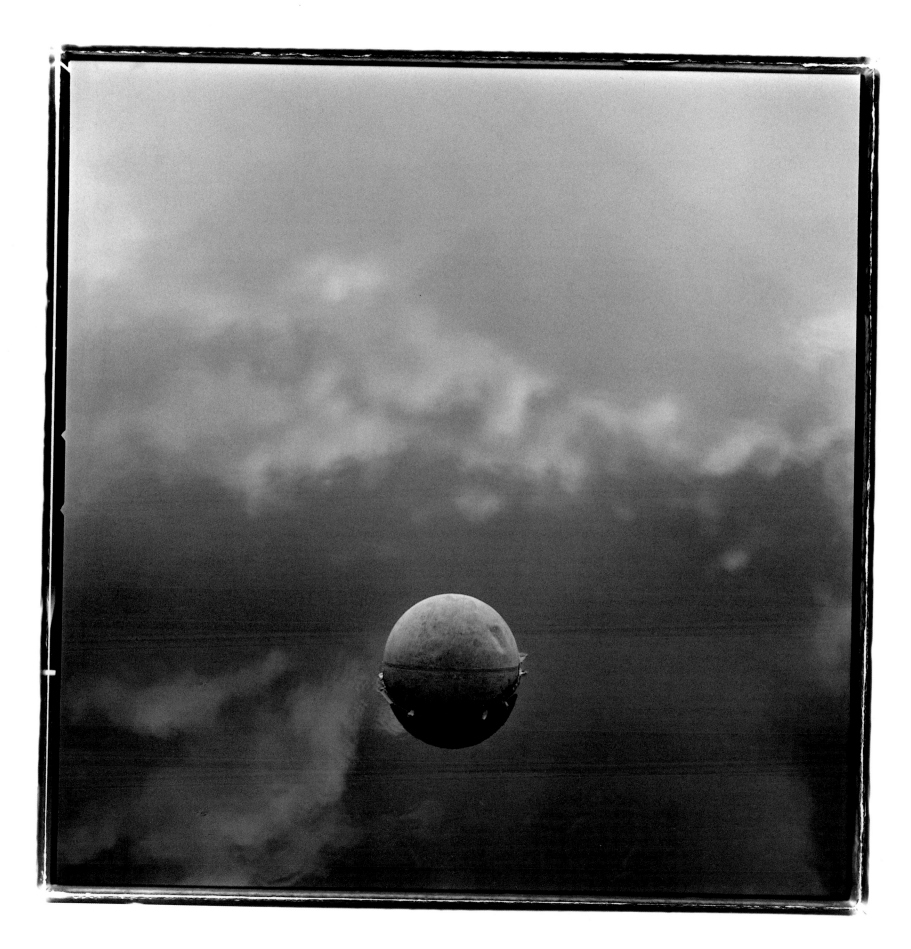

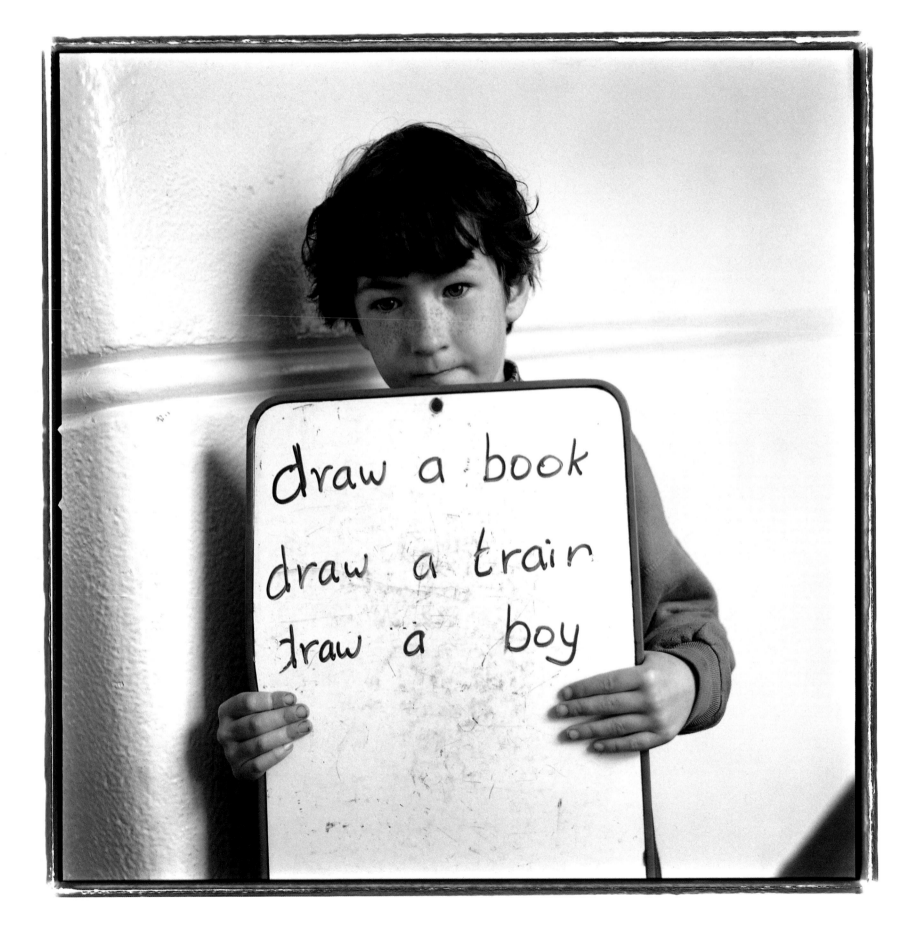

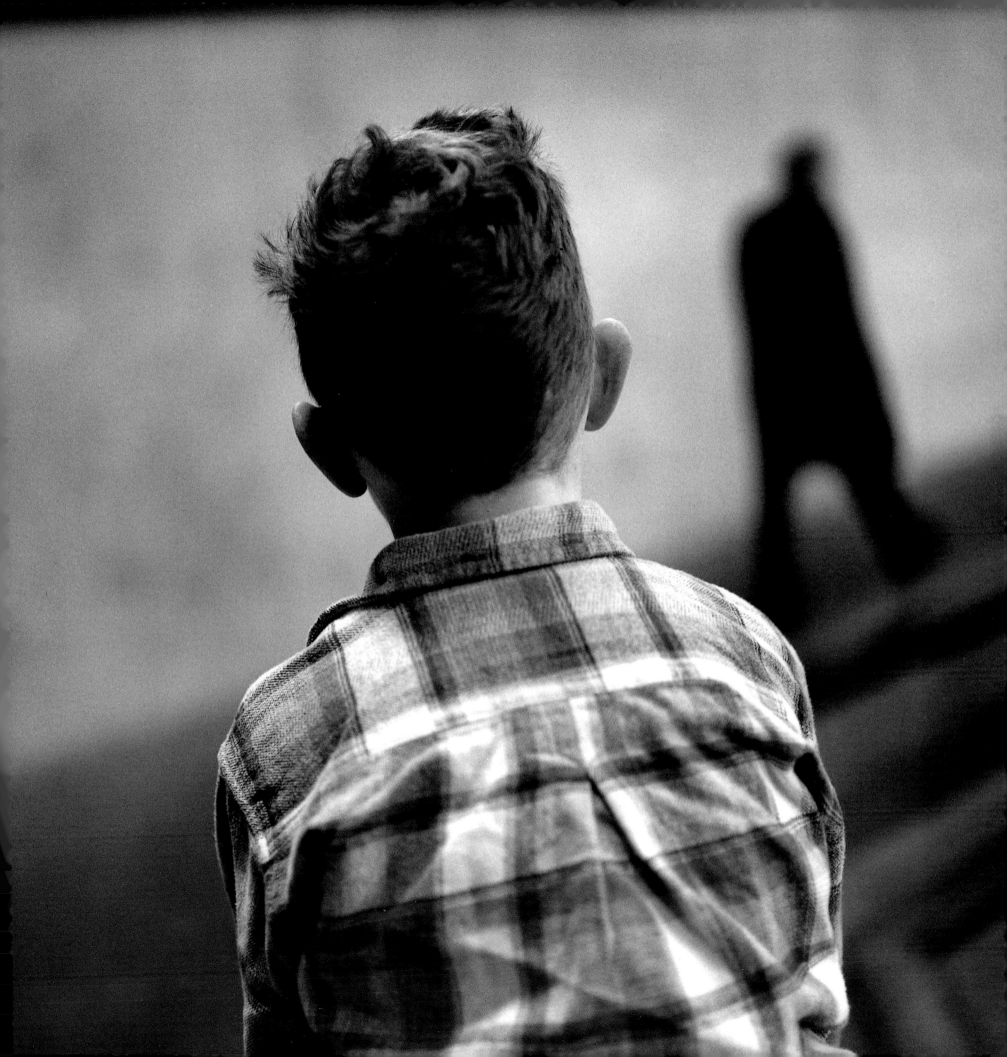

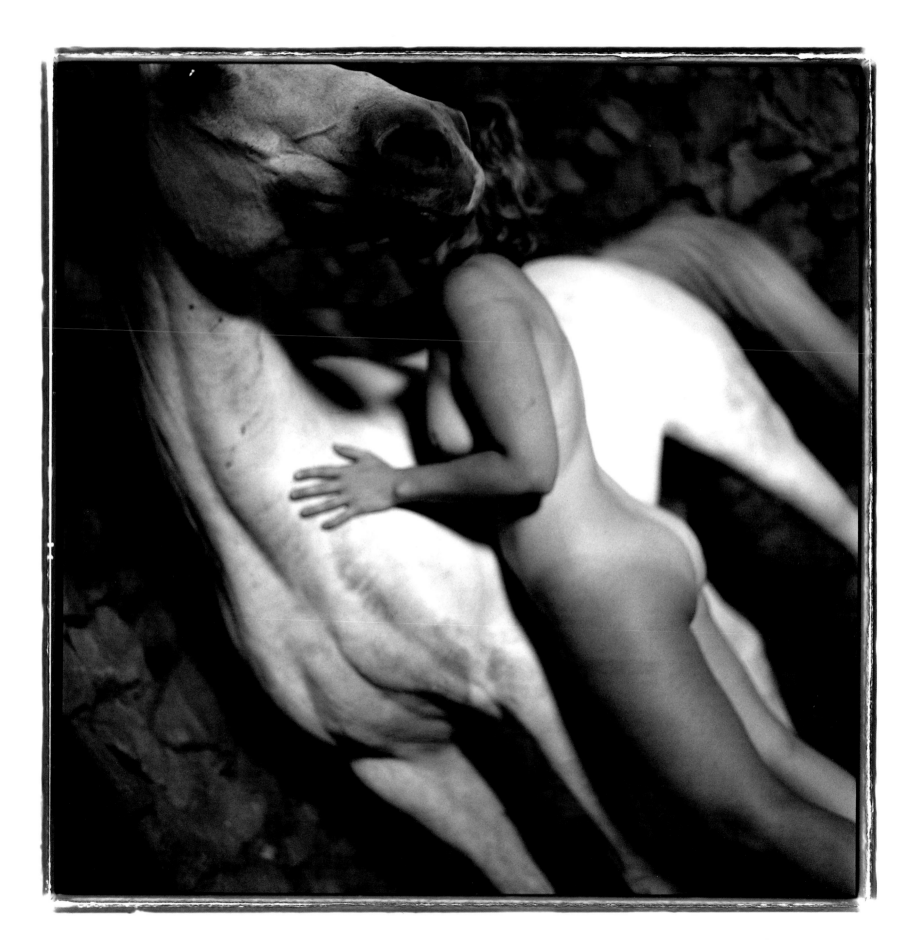

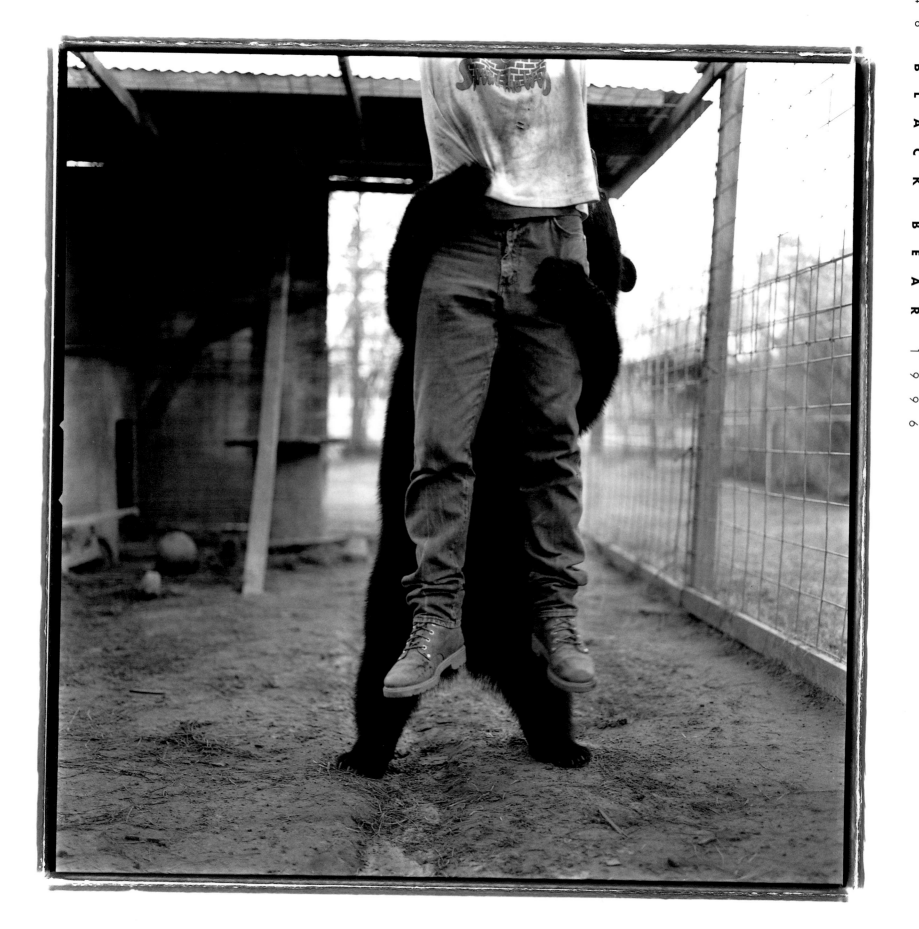

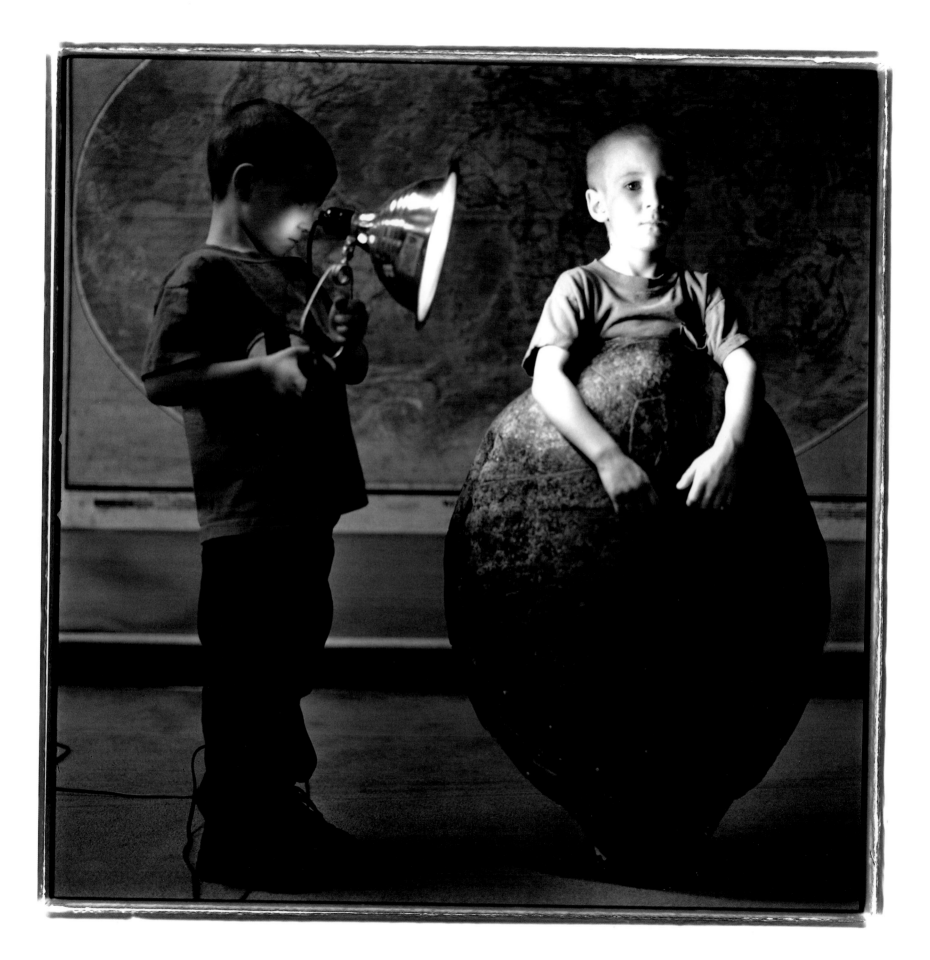

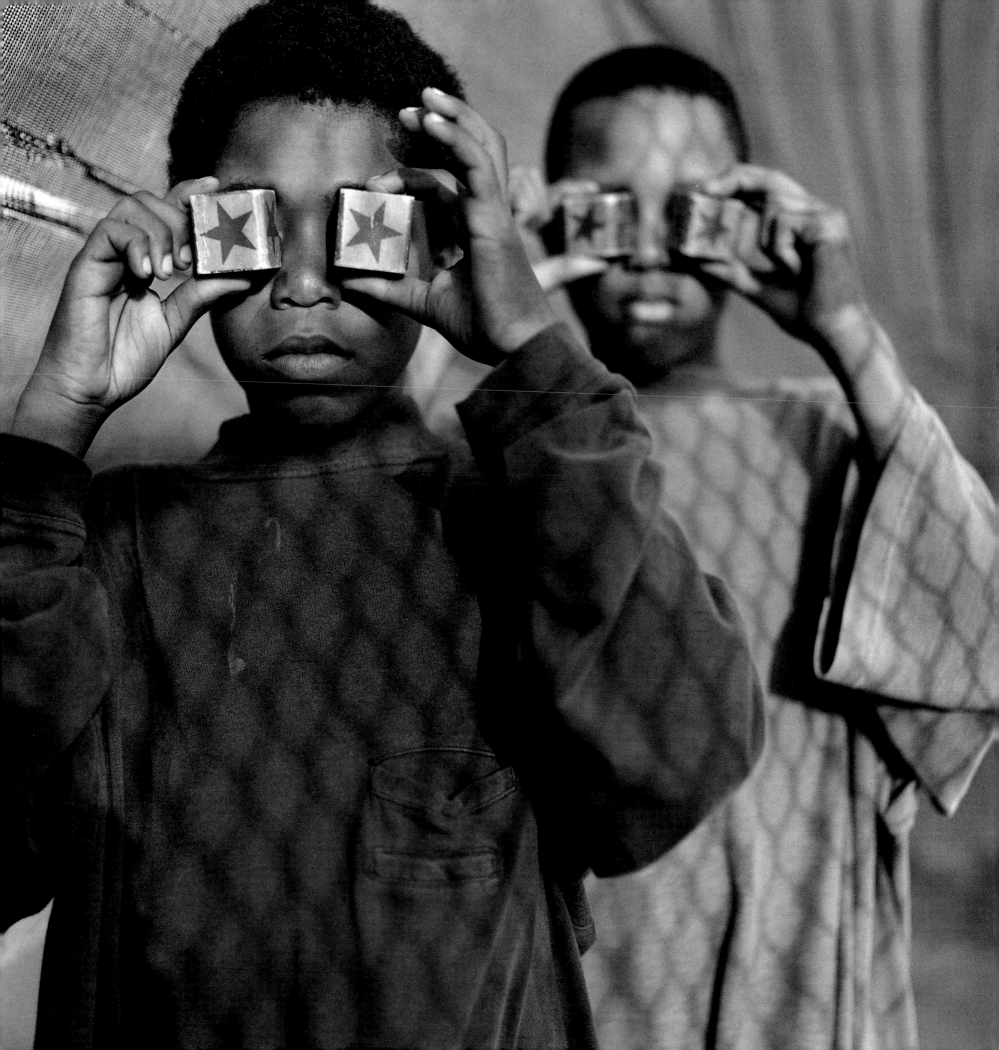

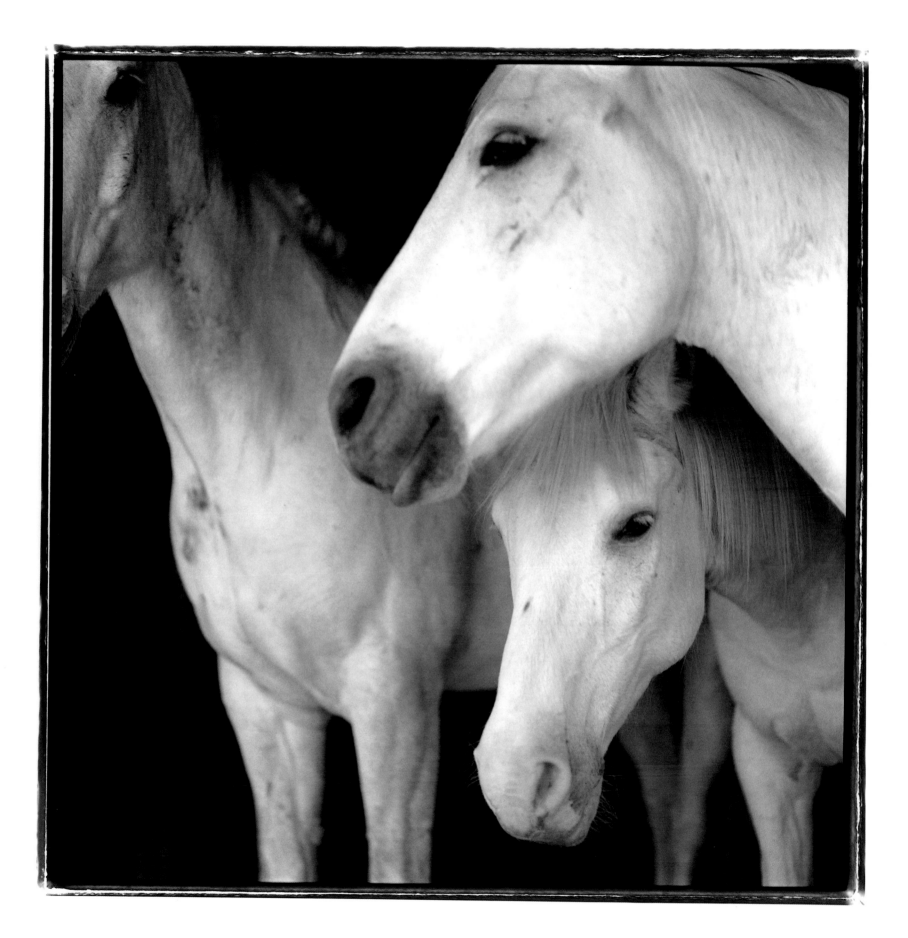

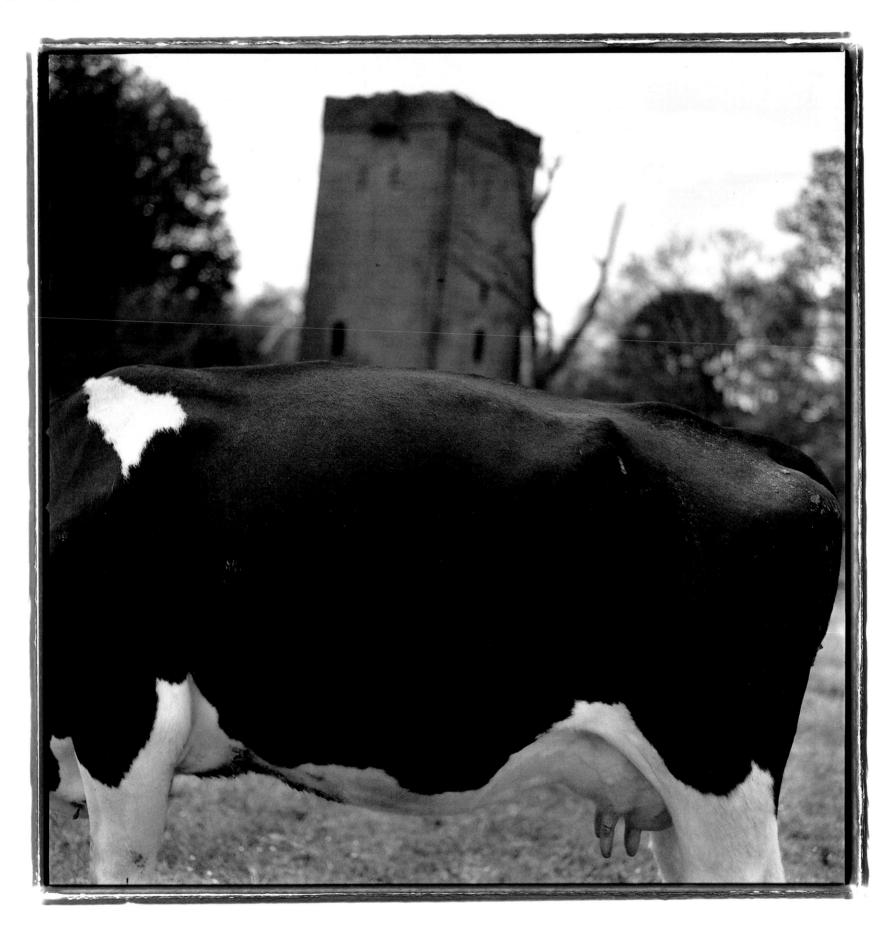

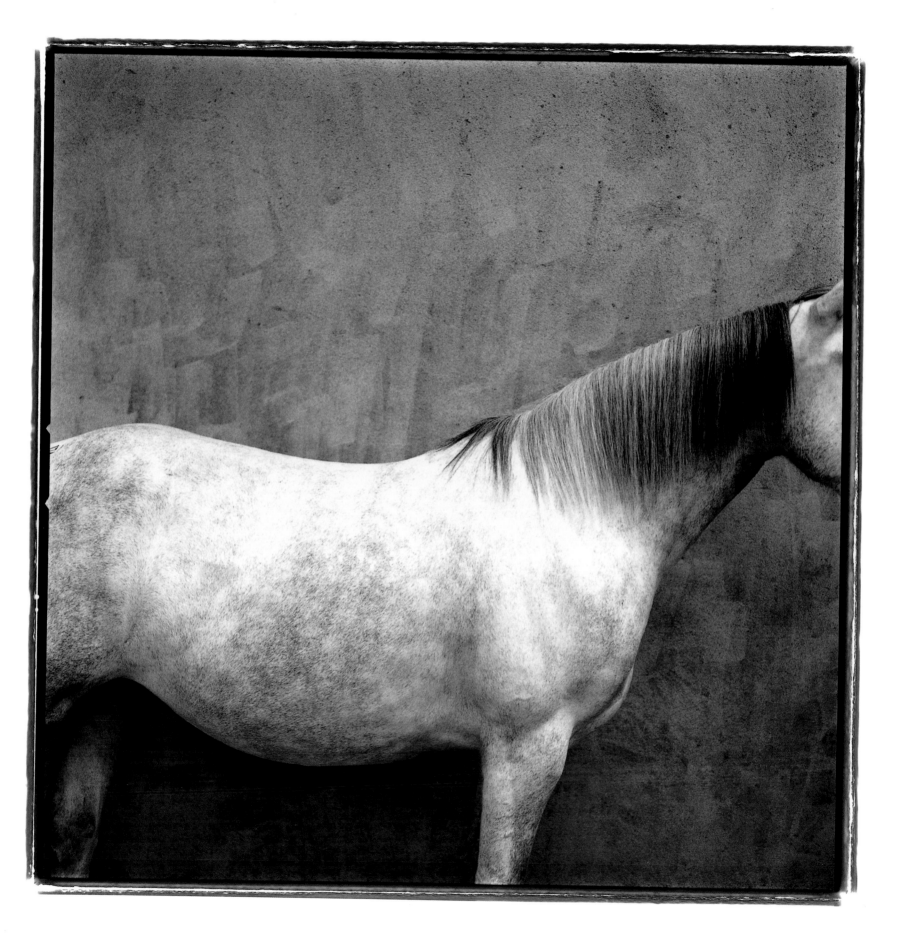

53 **CONNEMARA PONY** 1996

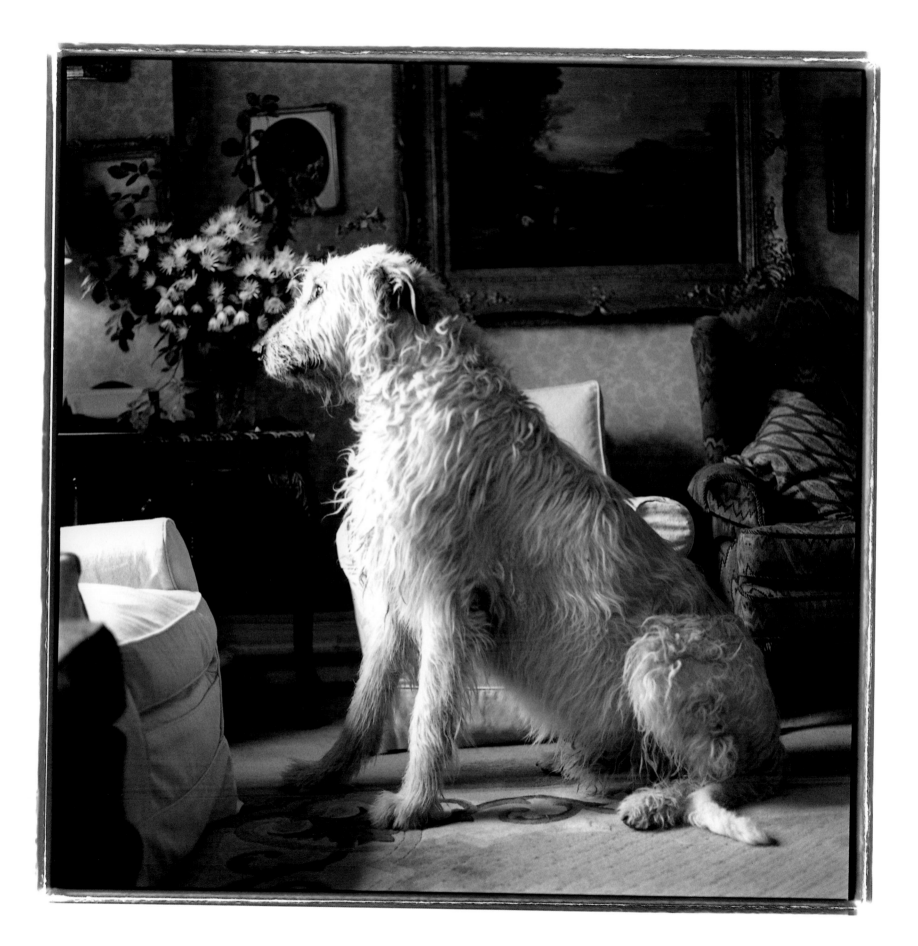

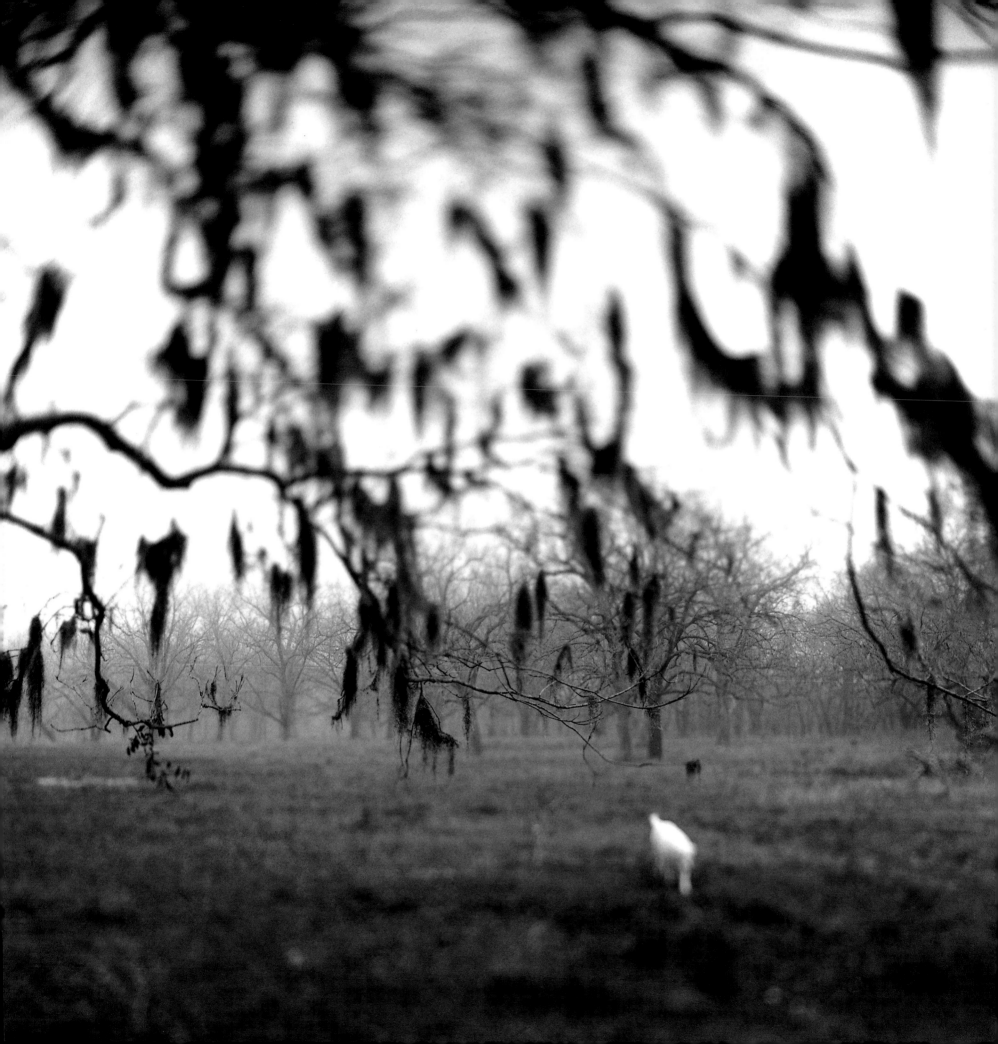

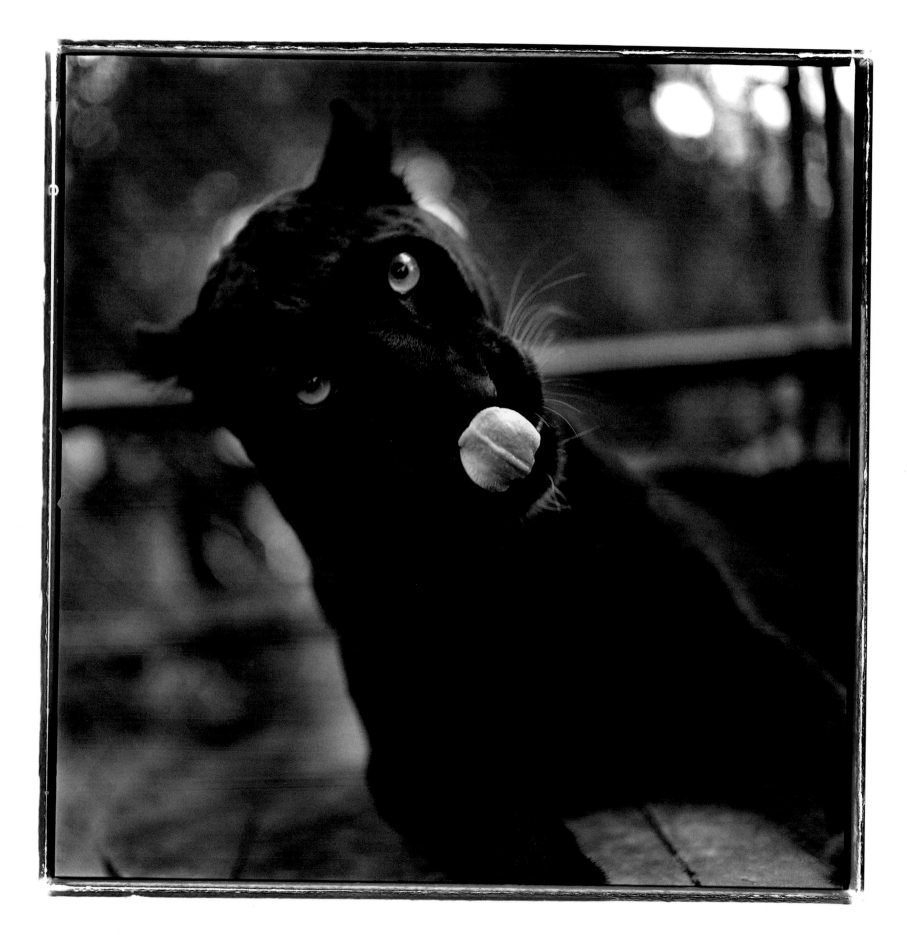

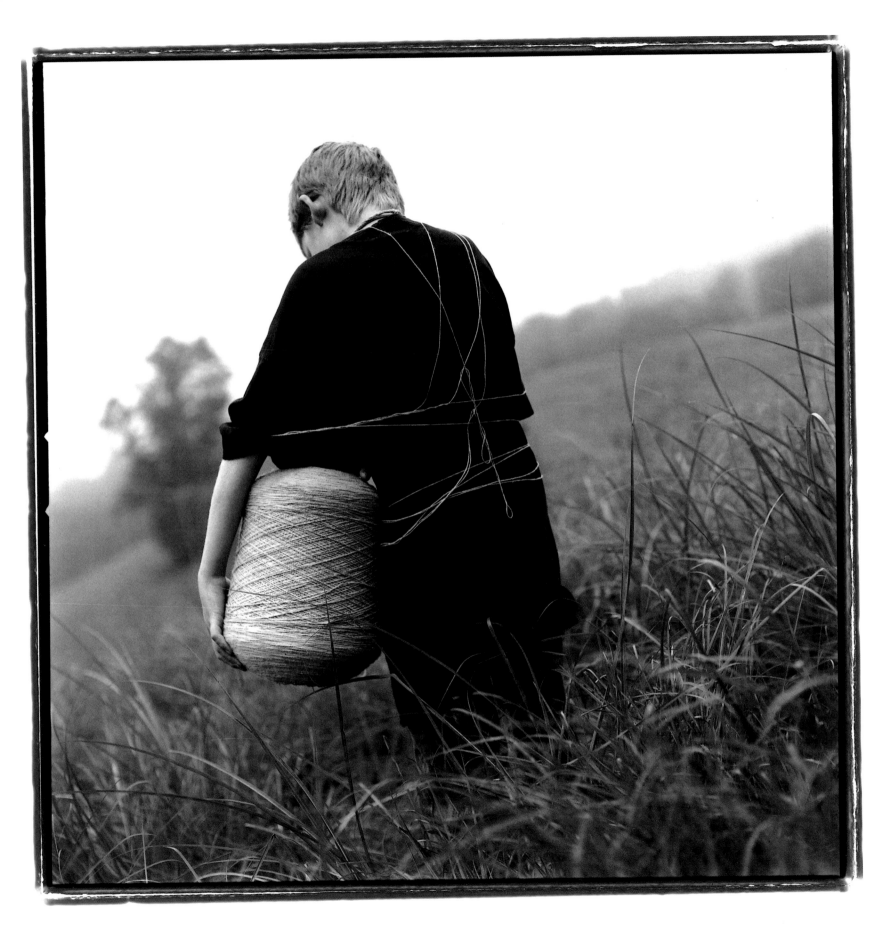

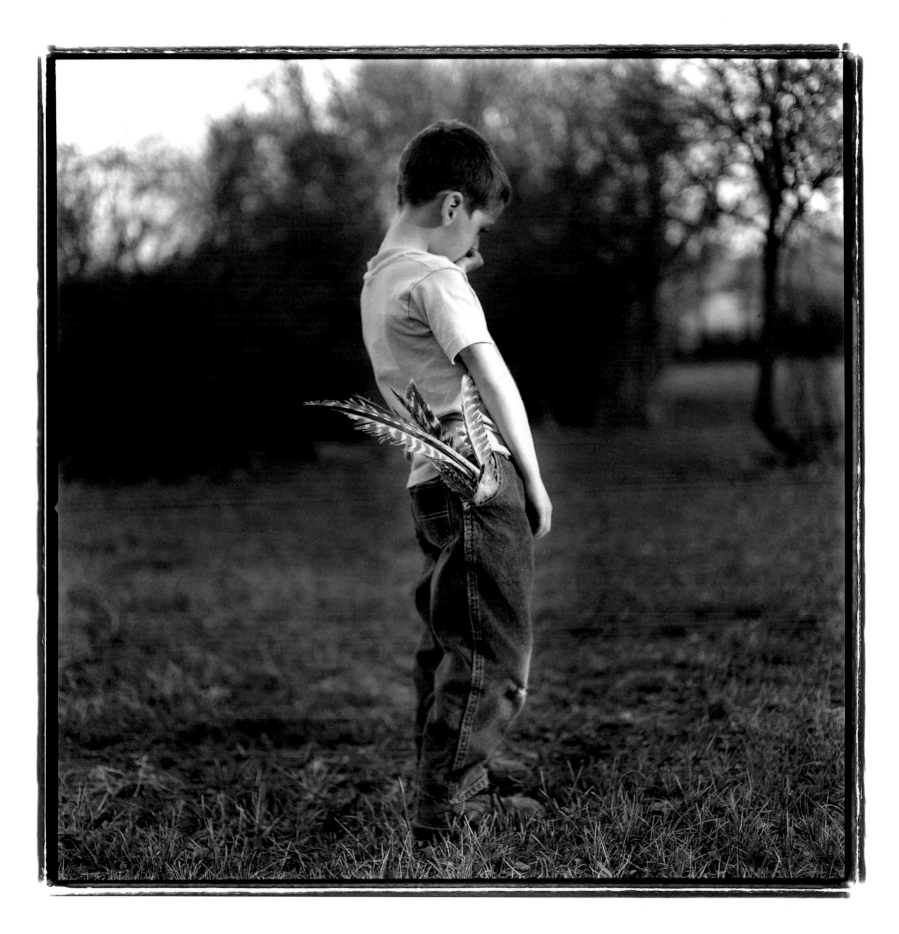

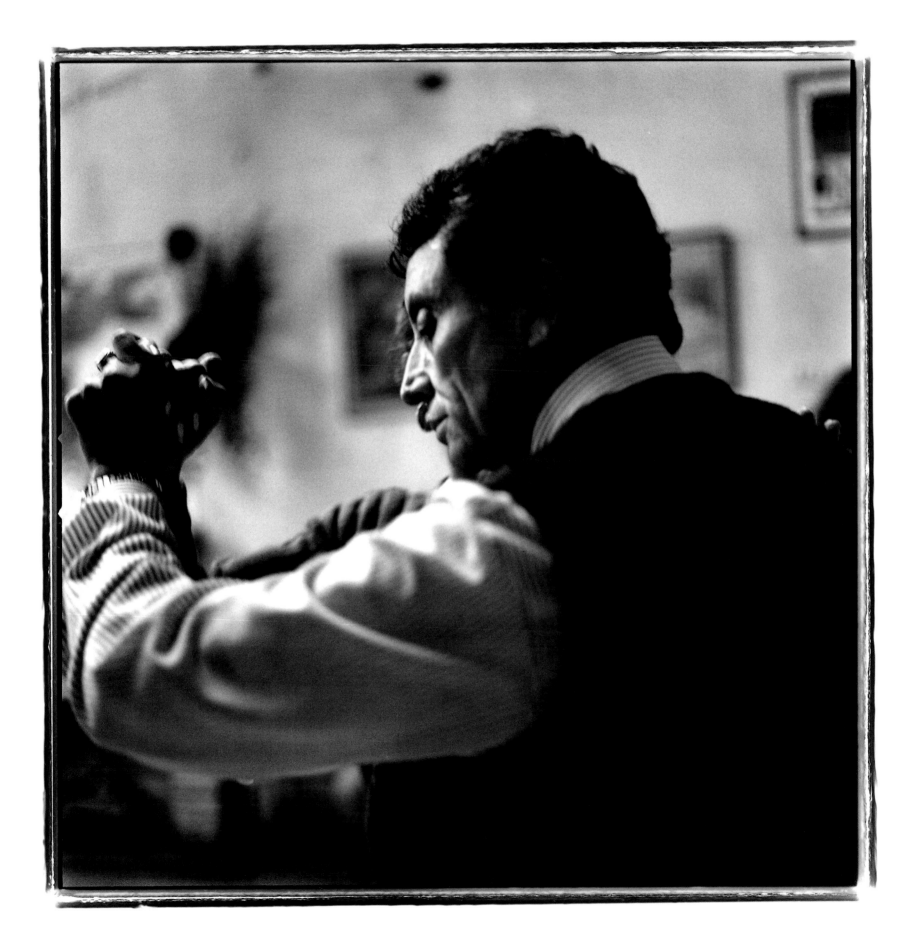

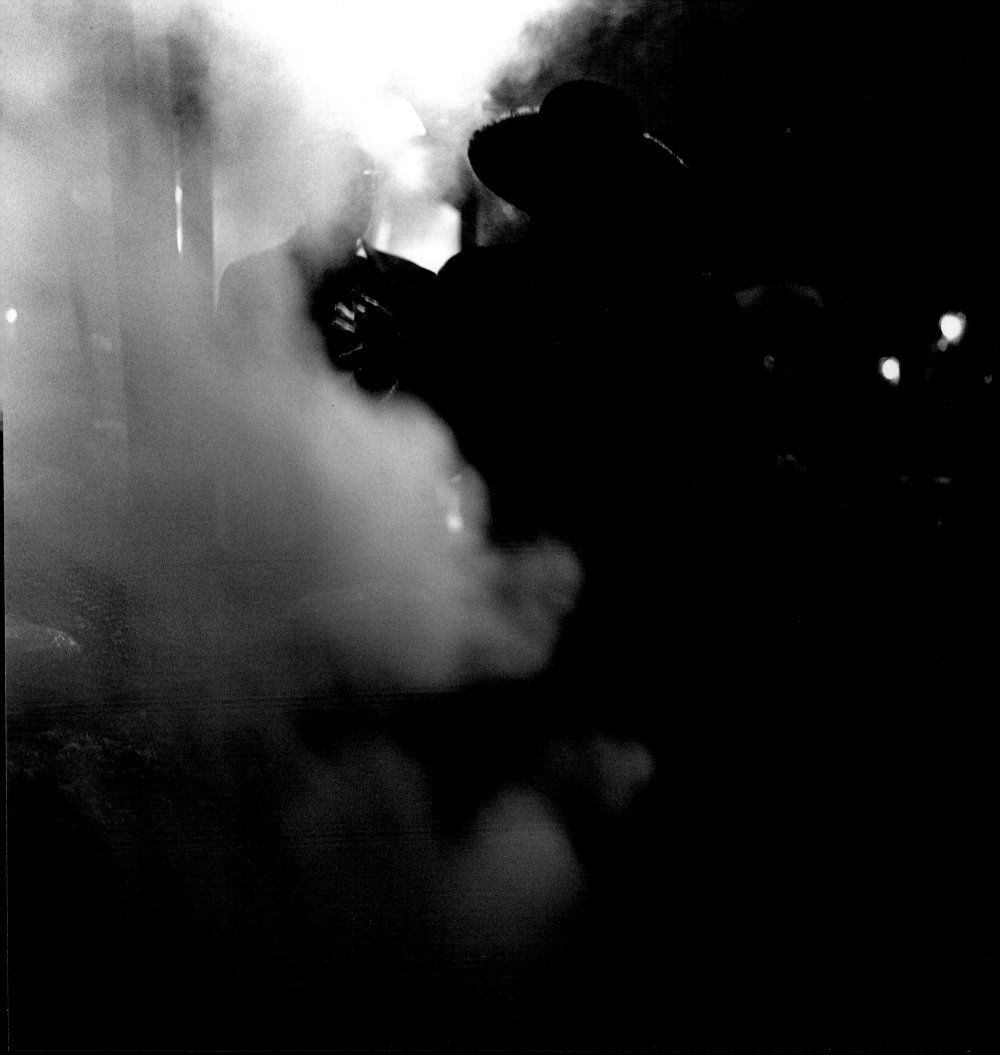

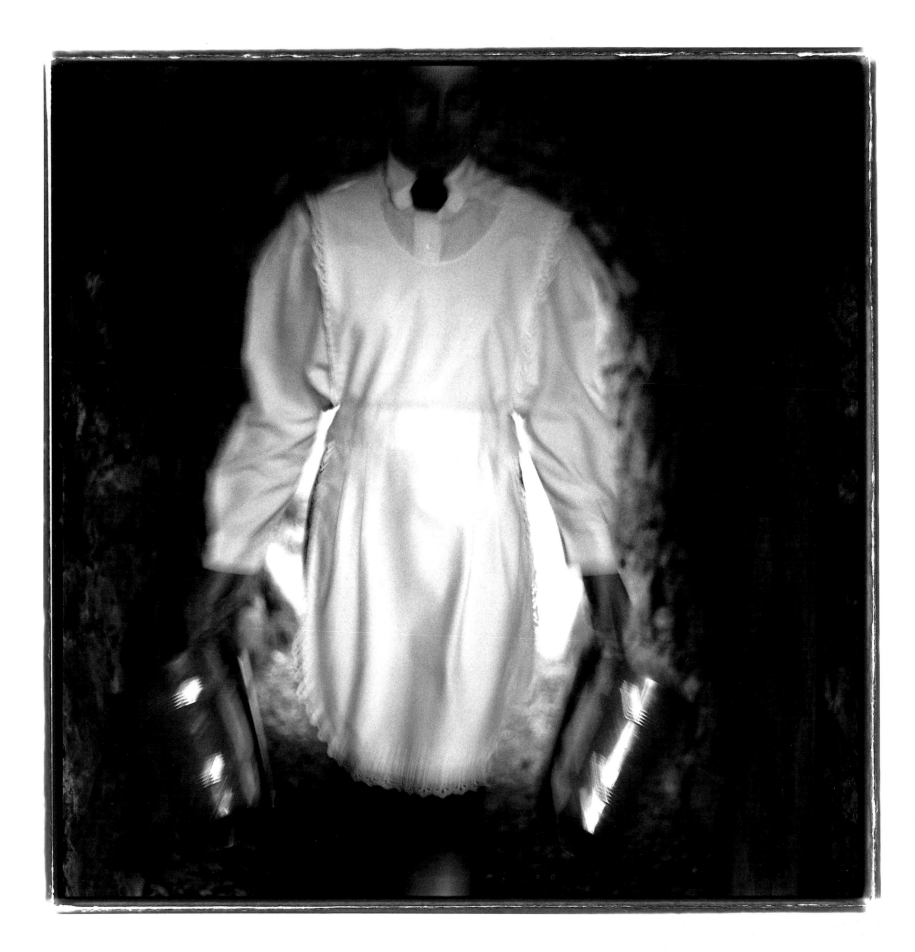

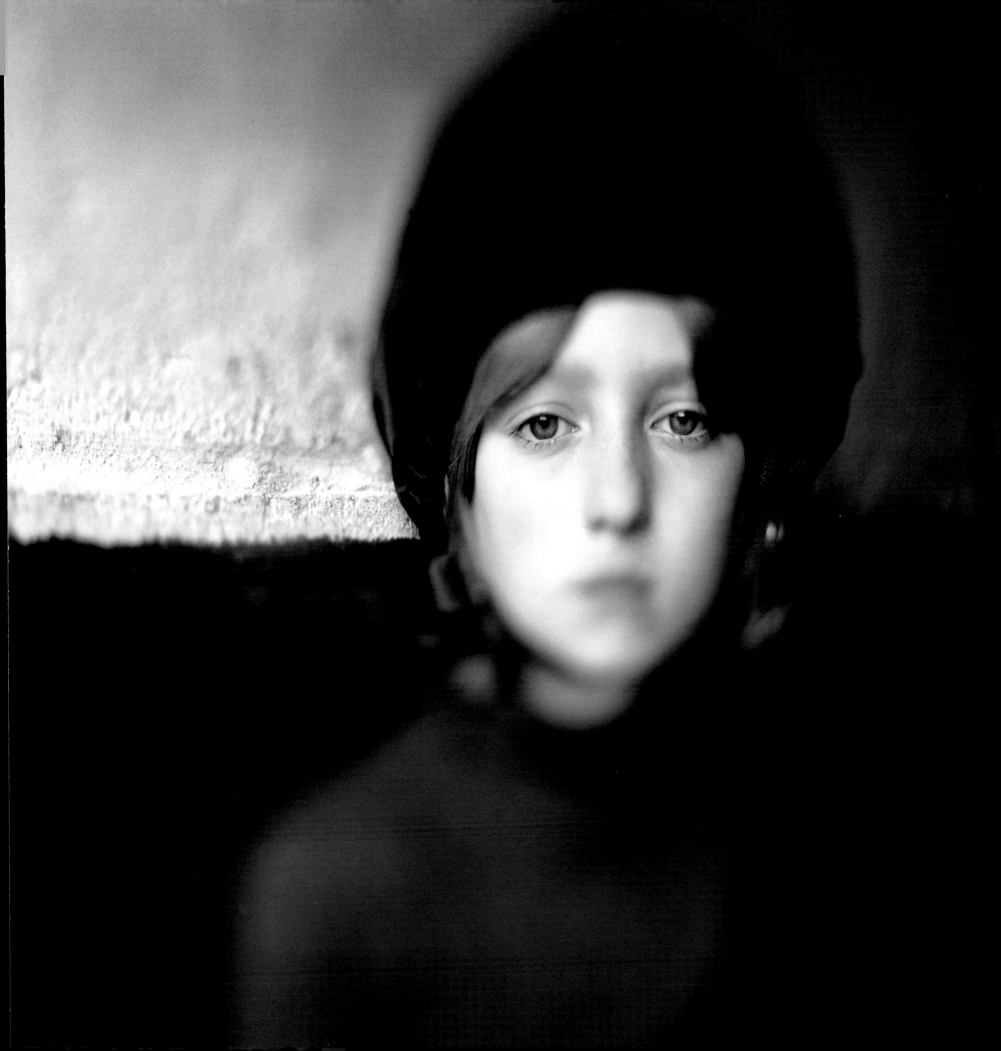

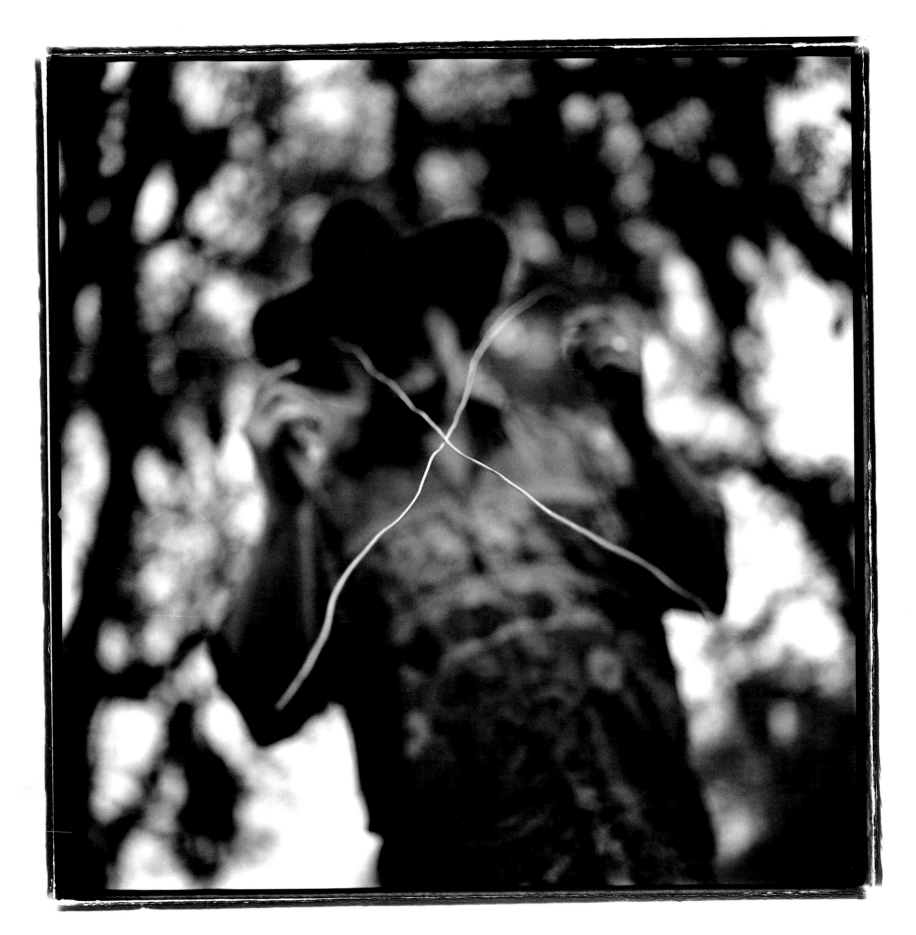

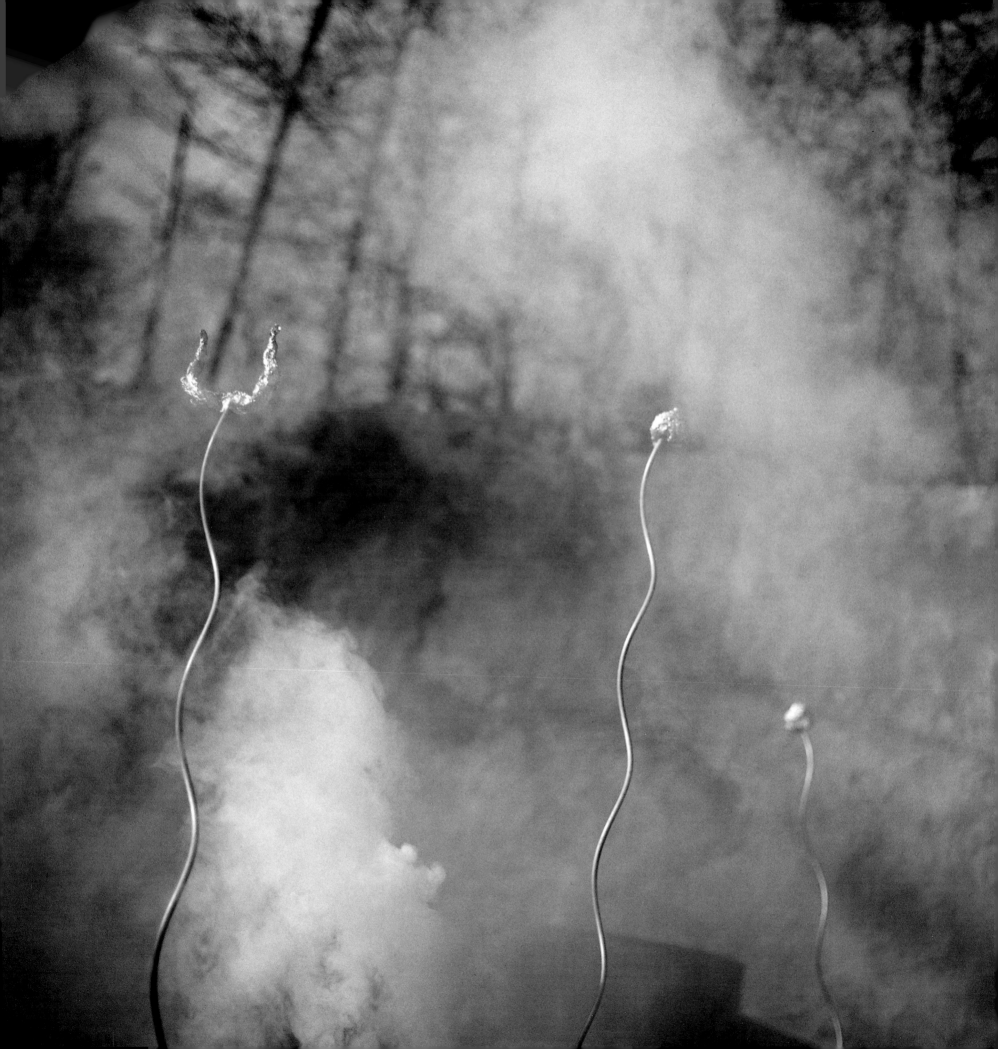

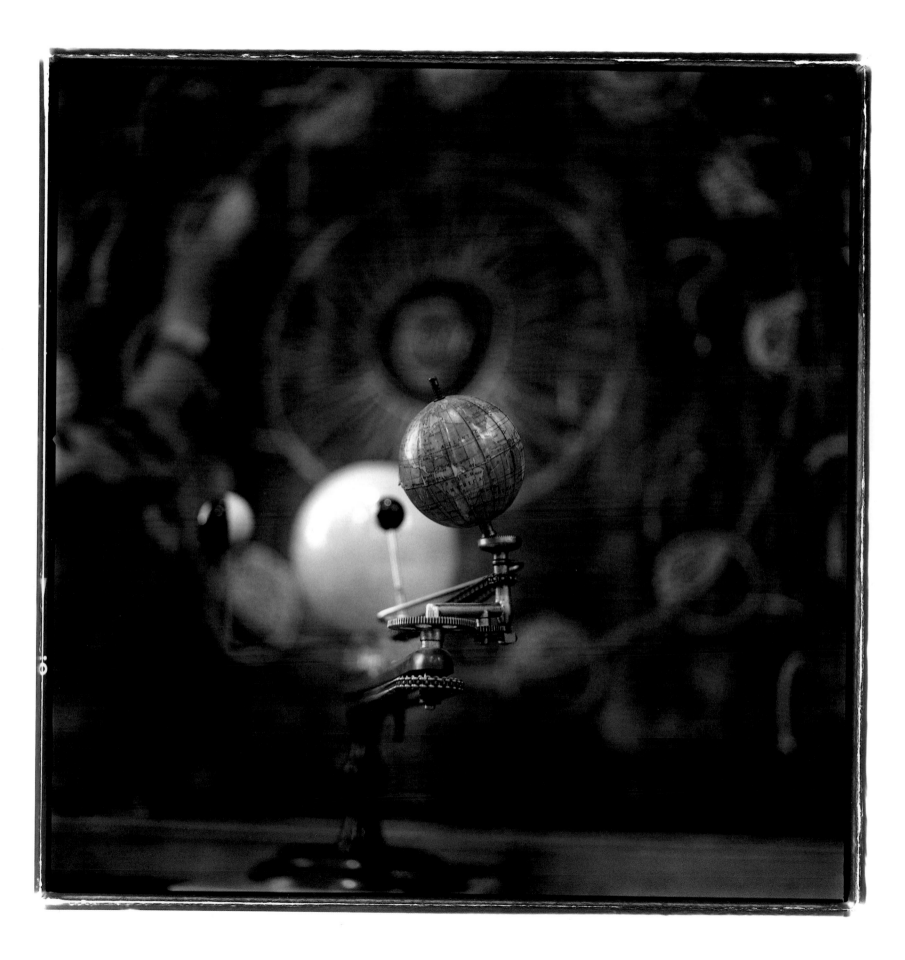

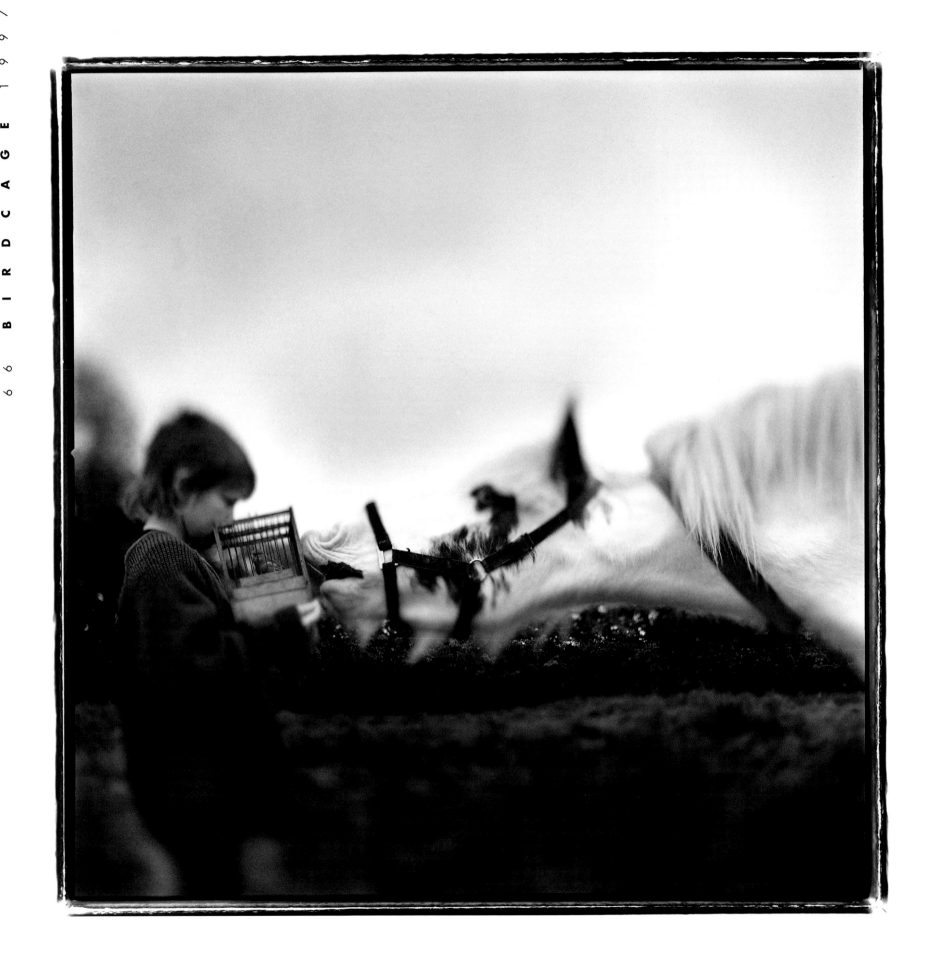

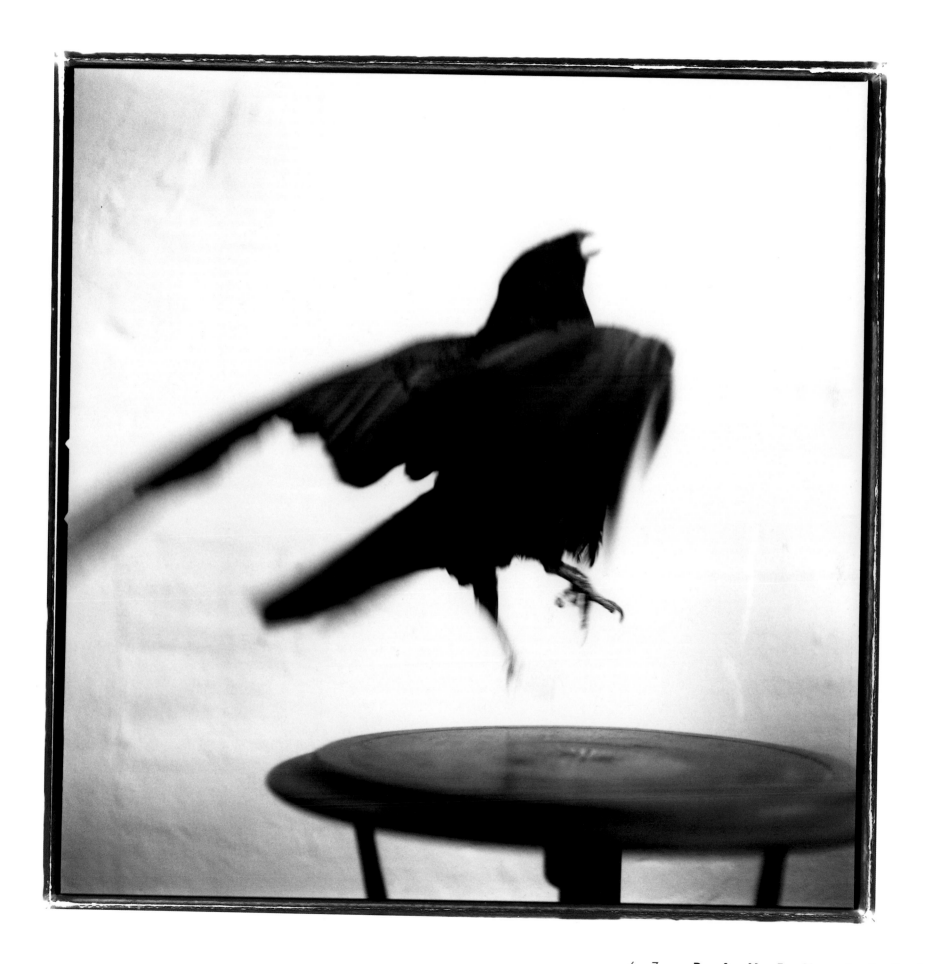

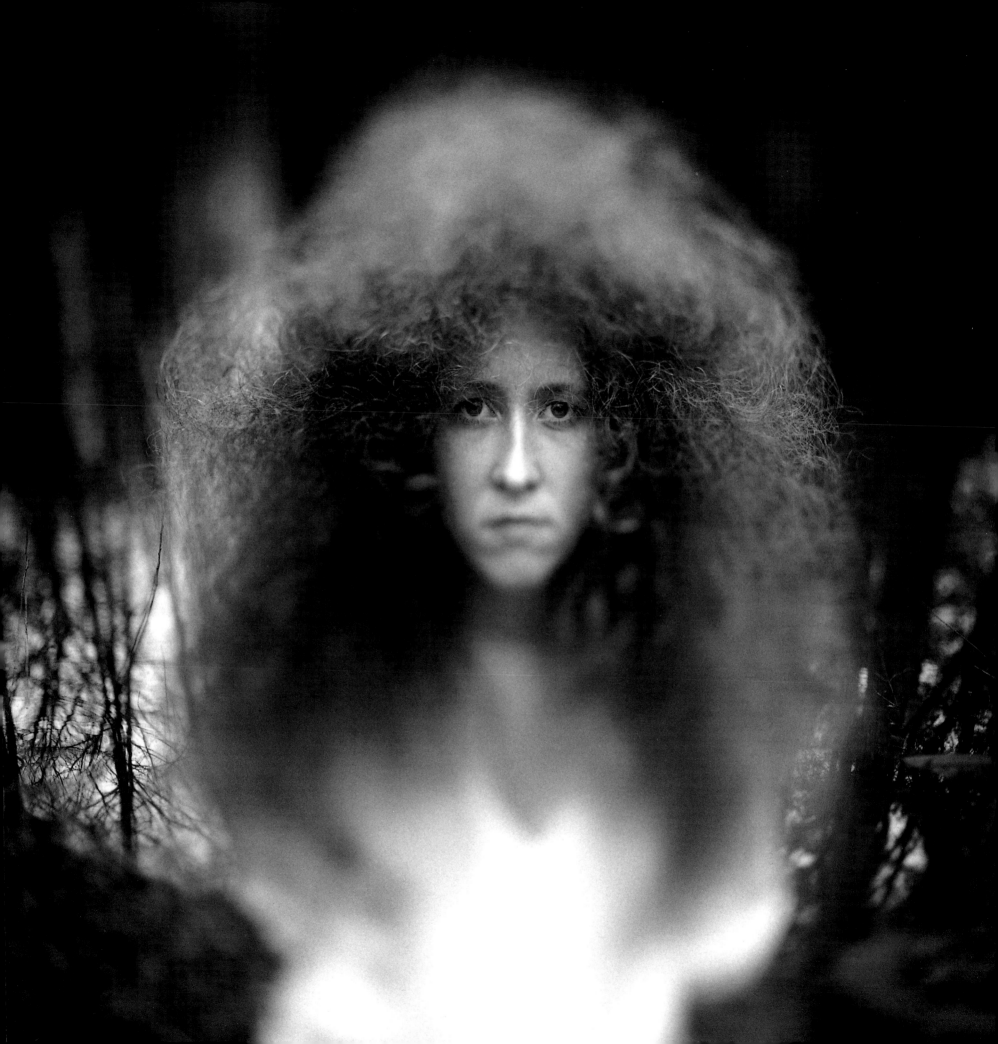

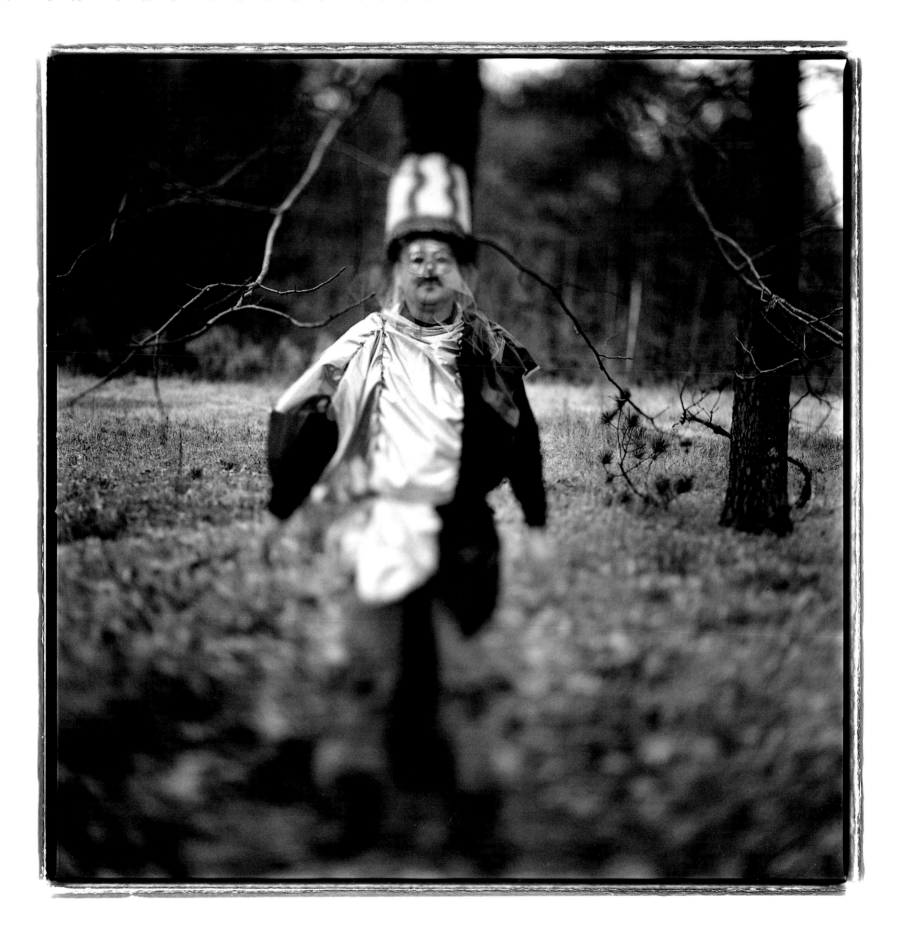

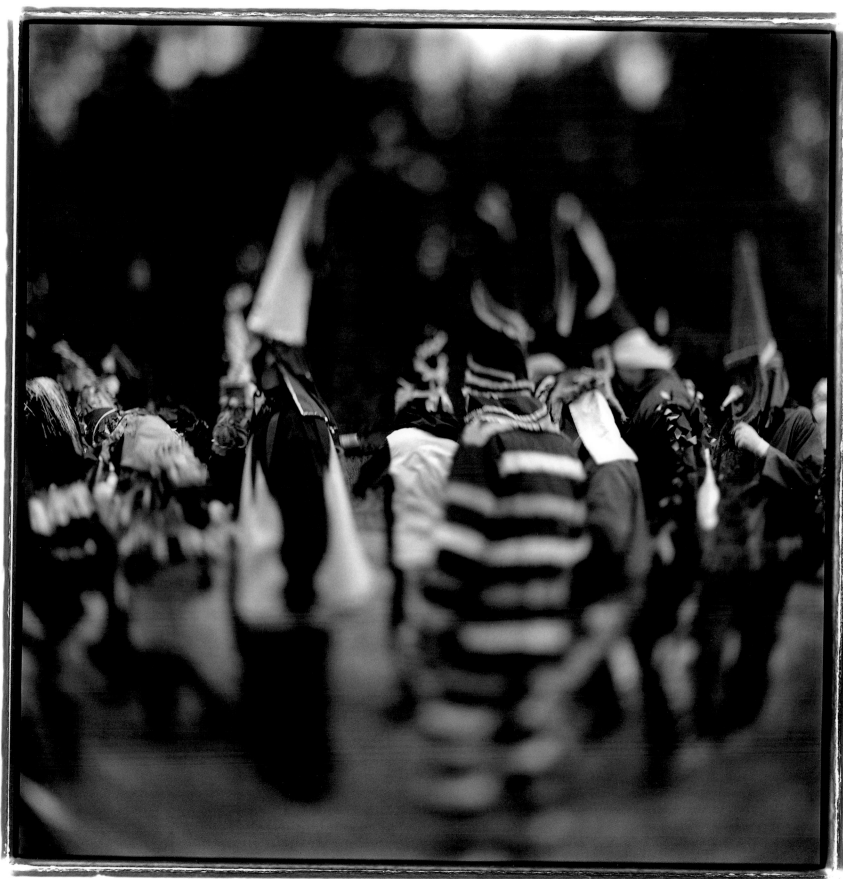

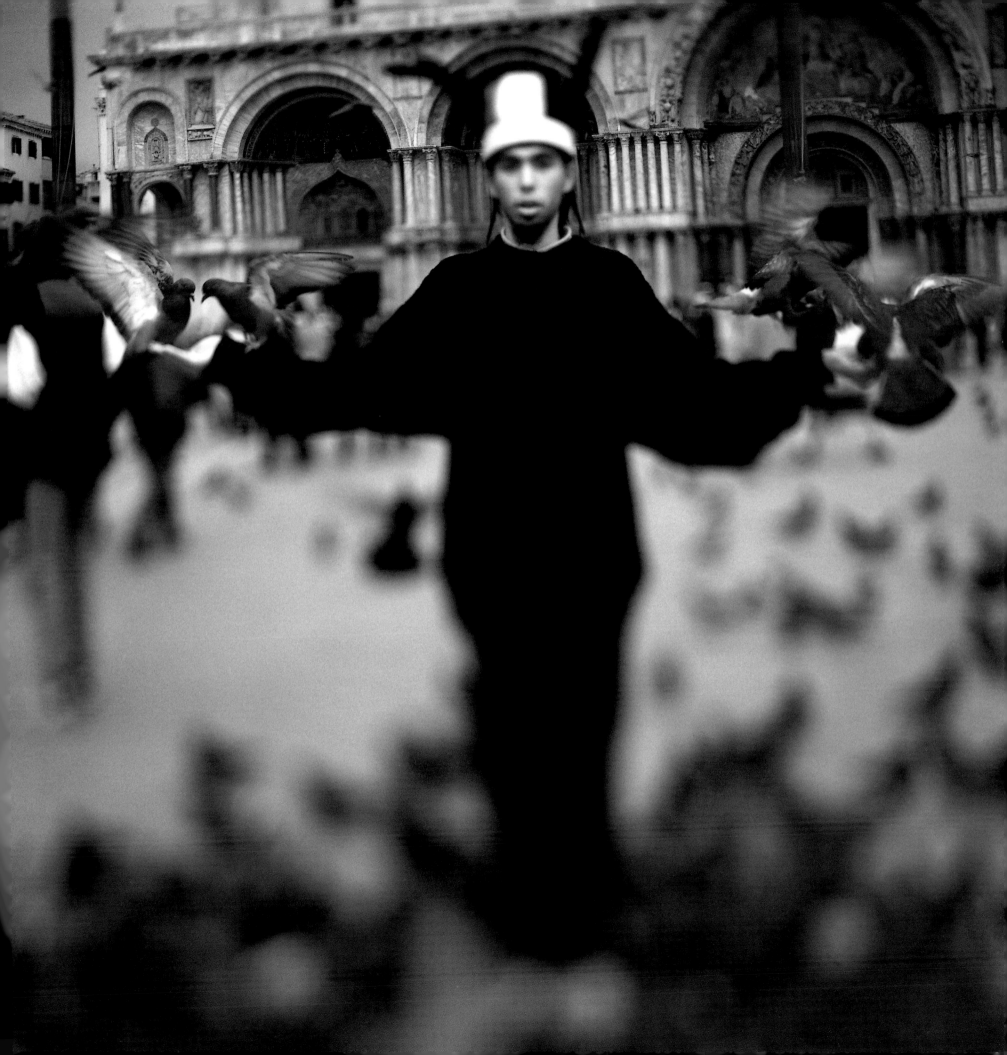

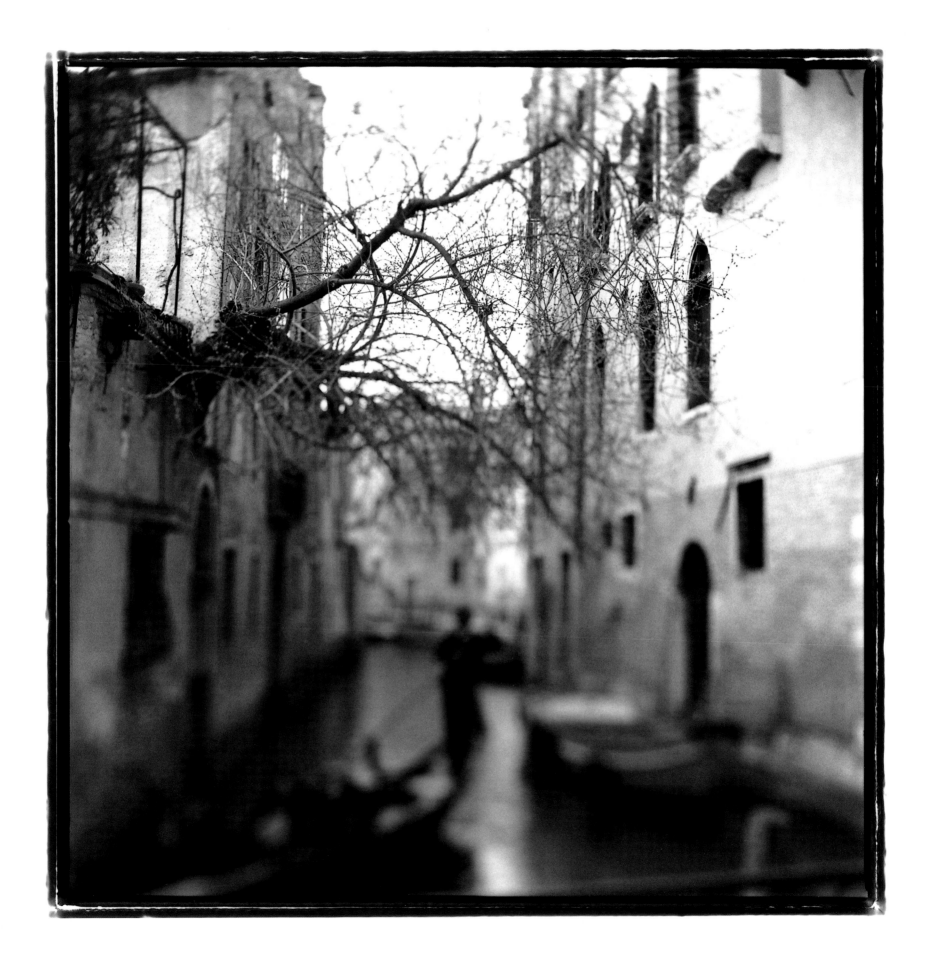

7 3 S A N M A R C O 1 9 9 7

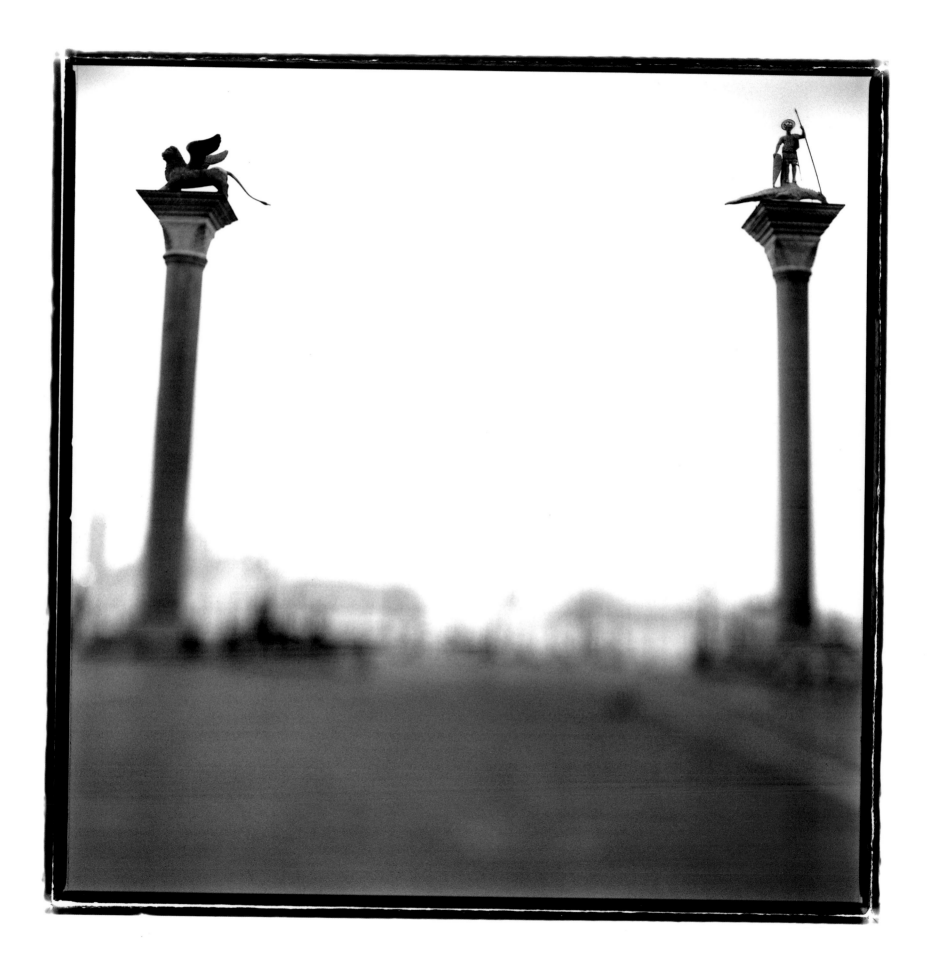

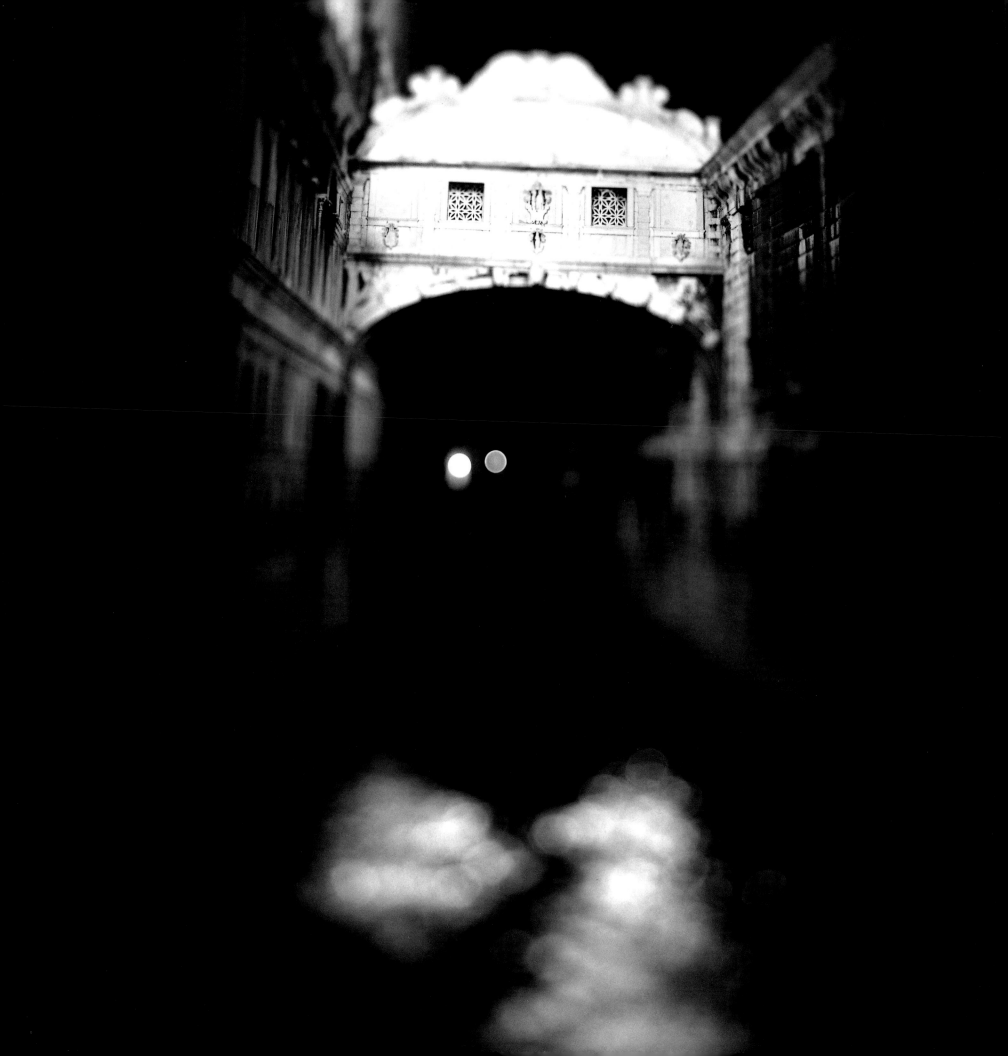

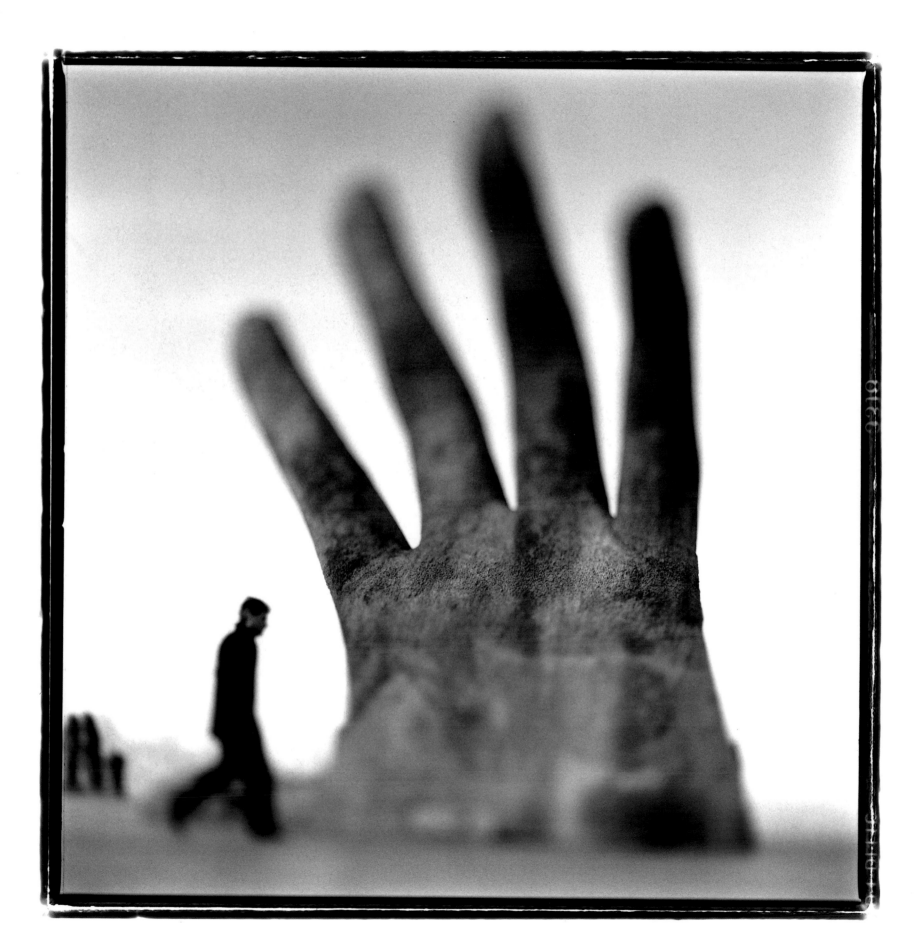

KEITH

CARTER

FRAGMENTS

I think there is an element of magic in photography—light, chemistry, precious metals—a certain alchemy. You can wield a camera like a magic wand almost. Murmur the right words and you can conjure up proof of a dream. I believe in wonder. I look for it in my life every day; I find it in the most ordinary things.

• • • •

My mother was a photographer of children. My father deserted our family when I was five. We lived in Beaumont, where I still live. Before her marriage my mother had traveled around photographing sorority girls in the Midwest. So when my father left, she rented a small space and began to photograph again. This time it was children.

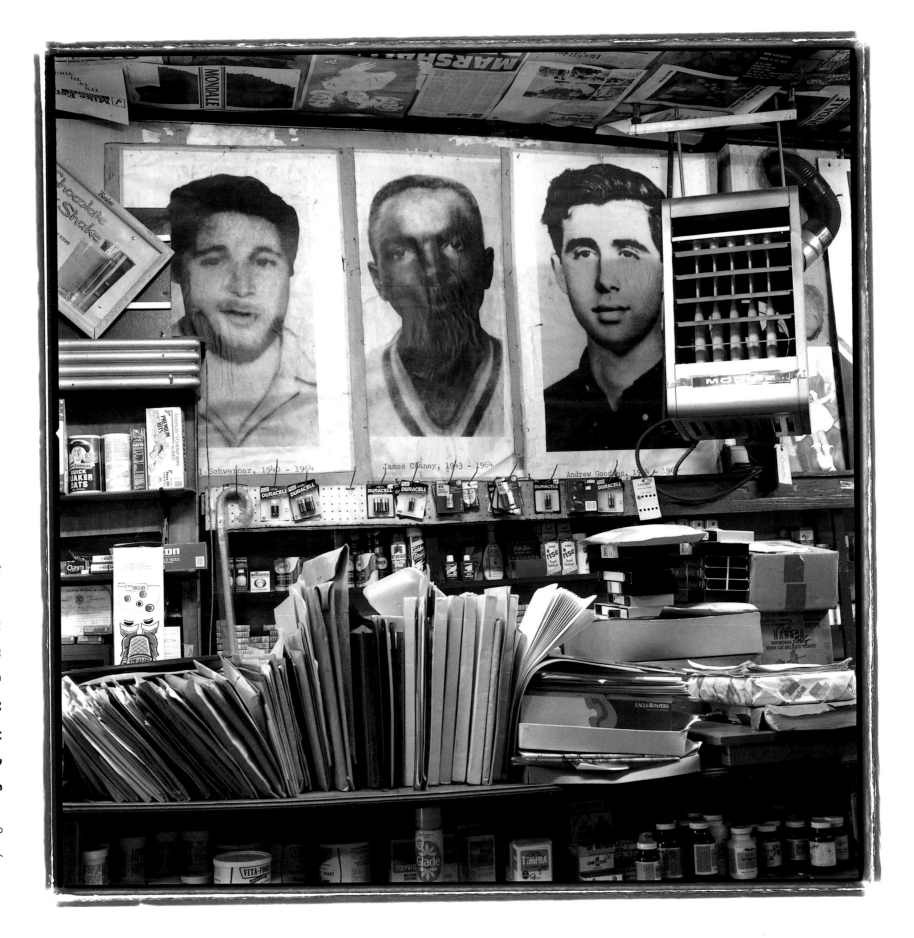

She would run a "Sunday Special" in the newspaper, advertising four 5" x 7" prints for $5.00, and she would have mothers and children lined up down the sidewalk. She would photograph sixty children on a Sunday afternoon and make three hundred bucks.

When I was five or six years old, my mother turned our apartment kitchen into a darkroom at night. My sister and I would have little pallets on the floor, and we'd be sort of dozing off; and I remember the orange light and the sound of running water, and every now and then getting up and watching as one of Mother's prints would come up in the developer.

I never really paid attention to her work or to photography in general until I was about twenty-one. I remember coming into our house and seeing a large stack of 16" x 20" prints against a wall—color photographs of children—and there was this almost clichéd image of a little girl in a straw hat in profile, leaning against a tree and holding a basket of kittens. But it stopped me dead in my tracks, and I can pinpoint that it was, in some respects, a small epiphany in my life; because what stopped me wasn't the picture so much—it was the light. She was just completely rimmed in light. I remember getting down on one knee where I could really look at it. That afternoon I asked my mother if I could borrow her camera. It was a twin-lens Rolleflex. I made some photographs and showed them to her. She said things like, "Oh, you have a nice sense of light," and "That's a good composition," or "You have a good eye." Things like that—just being encouraging. But by encouraging me, she gave me a certain confidence, a certain license to create. I've never really looked back.

When I was about twenty-three, I started traveling with my mother around the state, photographing children. I was a clown. I made the children smile, laugh, and she made the pictures. It was a great learning experience, and I did it for 15 years, not always as a clown. After a while she retired, and I did the photographs—

by my count, I did over 6000 sittings of children. It taught me a lot of things.

• • • •

From the beginning, I wanted to make art. I felt that very strongly, even though I stumbled around for a long time. The great thing is, it's twenty-five years later, and I feel that even more passionately now. I just want to make art.

• • • •

I have a friend who says, ". . . all great art reminds you of something you already knew, but didn't know you knew."

• • • •

My mentor was a sculptor, David Cargill, who lives in my hometown. Aside from my wife, Pat, David with his early advice helped shape my work the most. David had an interest in photography, a darkroom, and a life in art. He would look at my early work and talk to me about artistic matters. He would say things like, "Be ruthless with space; don't waste it. It's all you have to get your message across." Then he would crop and recompose my pictures. He would say, "Don't just look at photographs—don't just think like a photographer." He and his wife, Patty, had a magnificent art library. I guess the most important thing David did was to loan me books and to instill in me the feeling that photography could indeed be art. The first book he loaned me was on

Vermeer. He said, "Take this home and look at it. Pay attention to his use of perspective. He paints much like a photographer sees. Look at his use of natural light, his gestures." Then he loaned me Cartier-Bresson's *The Decisive Moment*, which just blew me away. Then books on Bosch, Rousseau, and Ansel Adams. So, for a while, I became whoever's work I could get my hands on. I'm self taught. I learned to print by trying to make my work match the tonal scale of the reproductions in the photography books. At that point, I had never really seen a great original print.

• • • •

I read James Agee's *Let Us Now Praise Famous Men* when I was about twenty-two or twenty-three. I didn't understand Walker Evans' photographs in those days, but the prose electrified me. I've never been able to recover from that. It's probably why I'm attracted to rural areas. At that time there was no photography being shown in this region, so I was working pretty much in a vacuum. I was desperately seeking some kind of validation, some kind of direction or guidance.

• • • •

When I was twenty-five I took the bus to New York City for the first time. I had written the Museum of Modern Art, asking if I could look at prints in their collection. They wrote back and said yes. At the time, I was working as a picture framer and photographing in black and white on the side. I thought I had saved enough money, if I was careful, to stay a month. I was wrong; I made it three weeks. It was February, and I stayed in the least expensive place listed in my guide book,

the Hotel Albert in the Village. The elevator didn't work, so I had to climb flights of stairs, stepping over all these stoned people. But for two hours a day, three days a week, for three weeks, I went to the Museum of Modern Art, put on little white gloves, and interns brought me boxes of photographs that I had only dreamed of seeing—images I had only seen in books. I think I was a little obsessed at that point. It was the first time I'd ever heard of Paul Strand or Eugene Atget. I would look at an Ansel Adams print and compare it to a Strand and try to figure out why they struck me so differently. I was searching for ways to make my prints more expressive. I was on fire, and I was in heaven for those few hours each day. Then I would go to galleries and see what was going on in the contemporary art world. I think of that experience now as my three-week graduate education.

• • • •

Another great epiphany in my life came when I went to a film festival in Galveston because Horton Foote, the playwright, was going to speak. I was sitting in the Galveston Opera House about to fall asleep—the panel discussion was a real snoozerama—when finally, Horton's turn came; and this portly, handsome older man said, "Well, when I was a boy growing up in Wharton (Texas), I wanted to do art, and I was told if you wanted to do art you had to do or know a couple of things. You had to know the history of your medium; you had to know all that had come before you. . . ." I thought, "Yep, I agree with that." ". . . and you also had to be a product of your own times. You had to write about your generation, what you knew, your times." I thought, "Yep, I know that." And then he said, "But for me, that wasn't enough. For me, I had to belong to a place." Well, when he said that, I felt like St. Paul on the road to Damascus. I felt this great weight lifted off my shoulders. I sat up, and I had chills,

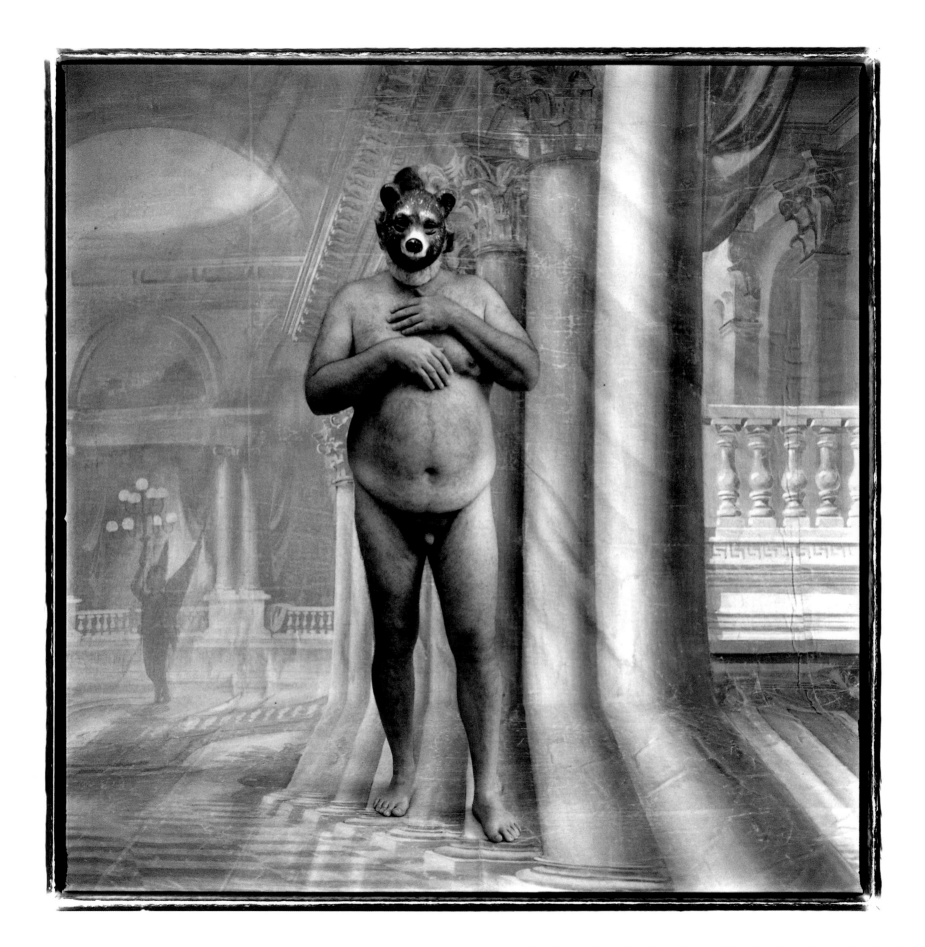

and I thought, "Oh, Jesus, I belong to a place. Why am I thinking I have to go to New Guinea or somewhere exotic to make a picture that counts, when I live in the most exotic place I know. I live in this peculiar region of East Texas that has everything."

• • • •

It took me a decade to really earn a living as a photographer—ten years to make any kind of a living at all. I did every sort of portrait and commercial assignment I could get my hands on. But all the time I worked on my own pictures too. That was my focus. It took me sixteen years to publish a book. It's twenty-odd years later now, I've had six books published, I occasionally take outside assignments, and I teach. I ask my students if they can live so long with that kind of ambiguity in their lives. Can they work on a project for a decade without knowing whether it will ever come to fruition?

• • • •

I enjoy teaching, and I enjoy my students. I have this self-centered mission. Living where I do, teaching at a state university that mainly serves a few essentially rural counties, I have a lot of students who are hungry to learn but who have not really been out there away from home a lot. Some of them aren't going to travel that far, and I want them to be aware that art exists and can be made in their own backyard, and I want them to go away with a sense that life is marvelous no matter where you are, and if you don't leave Mauriceville ever, you can still have a highly fulfilled, interesting life. The world is full of people who do it—it's a matter of attitude. So in some respects, I try to teach them art, the art of photography. On another level, I have this slightly

hidden agenda to make them proud of who they are and where they come from.

• • • •

As best I can, I've tried to remove most of what is superfluous from my life. I try to put myself in positions—in physical locations—where the possibility exists to be astonished. I also try, as William Stafford said, ". . . to be on guard against perfection."

• • • •

When I work, I look for an interesting area, or place, and try to make it intimate. If, as happens nowadays, I find myself in a strange city, I look for a neighborhood, or a single block, and work there. I just generally try to rein things in, rather than get too scattered.

• • • •

I print early in the morning, 5:30 a.m. until around 9:00 or 10:00, before my other responsibilities kick in. Sometimes I print a little in the afternoon. If I'm printing new work, I can print two, maybe three, new negatives. If I'm printing older work, I can print maybe four. I don't dwell on prints. I don't dwell on making proof prints to look at first. I just go straight for it. I work with a certain contained intention and expectation.

• • • •

I write messages to myself in the darkroom. I write them on shelves; I write them on the

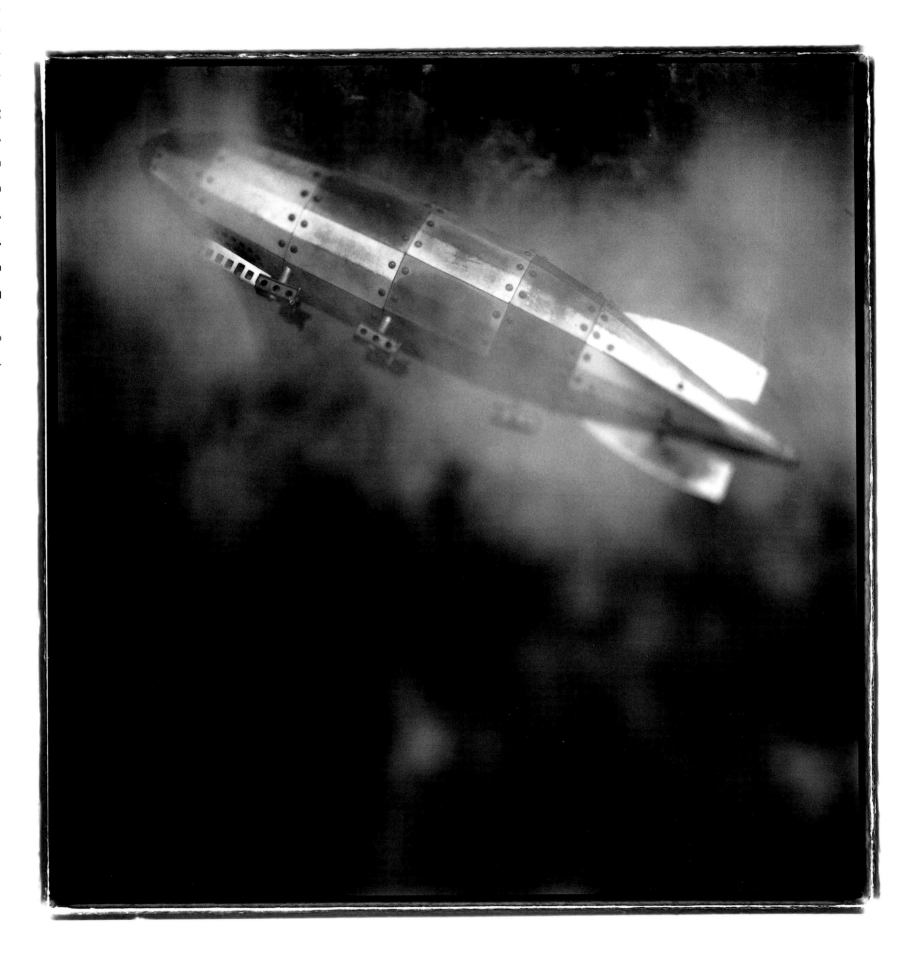

walls; I tape them to my enlarger—things other people have said that I want to remember. Wallace Stevens: "Poetry must almost successfully resist intelligence." Reynolds Price: "Nobody under forty can believe that nearly everything is inherited." Robert Frank: "Above all, life for a photographer cannot be a matter of indifference." Ellen Gilchrist: "We live at the level of our language. Whatever we can articulate, we can imagine, develop, and explore." Aristotle: "The soul always begins a thought with an image." I need these things. I need to stay grounded, I need to stay focused. My pictures evolve around folktales, poems, real people's lives, animals. I don't just look at the thing itself or at the reality itself; I look around the edges for those little askew moments— kind of like what makes up our lives—those slightly awkward, lovely moments.

• • • •

I can trace a certain turning point in thinking about my work to a very nondescript picture I made in a cemetery in central Mexico. At that time (1981), I was still photographing the thing itself, things at a moment in time, kind of a classical definition of photography. I walked into the cemetery, knowing full well that when you walk into a cemetery you are not just treading, you are stomping dangerously close to a clichéd picture. But the old Mexican cemeteries are always fascinating places, so I wasn't planning to make a picture of anything, I was just going to wander around. I was sitting under a tree, and I looked up, and above me, caught in the branches, were some paper streamers left over from some sort of celebration. And kind of like a musician making a run in a scale, I raised my camera to my eye just to see what it would look like—and it was a great moment. It wasn't a good picture, but for the first time I was consciously trying to make an image that didn't deal with reality, that didn't deal with the thing—a cemetery—itself, but rather with its essence. And so I worked there in a sort of fiery heat for about fifteen minutes.

I knew I was making pictures that weren't very good, pictures that nobody, including Pat, would understand, pictures that I wasn't sure I even understood, but felt compelled to make. Taking those pictures gave me a certain courage I hadn't had before.

• • • •

My photographs are really about me. I think all art, to some extent, is about the maker.

• • • •

I photograph ghosts. Mostly they're my own, sometimes they belong to others.

• • • •

I've often thought of playing the camera like a blues player plays an instrument—just bend the note here and there or just run a scale, just twist it a little bit, just practice, and never, ever, ever give up, and sometimes some magic creeps in or sometimes you hit the right notes and a picture materializes where you didn't think it would.

• • • •

Today I think of myself as a portrait photographer. My idea of really successful portraits are those handprints found on cave walls that date from Paleolithic

times. Something made people like us crawl deep into secret places in the

earth and leave marks. They didn't just dip their hands in pigment;

they apparently blew pigment around their hands and made a negative print.

I guess maybe you could say they were the first negatives.

For me, a portrait is something that has a certain weight, a certain seriousness to it.

It's not just replicating an image of somebody or something. These days I treat everything

as a portrait, whether it's a safety pin hanging from a string in a woman's bedroom,

or a man witching for water in a field. They're the same. They are all equal. I try to give

them the same weight. My own idiosyncrasy is that, to me, it's all poetry. But since personal

idiosyncrasies are all we have to work with, we might as well hang them out there.

A successful portrait is about the maker, the viewer, and the subject.

It's about all three in nearly equal proportions. That's when a picture really works . . .

when it's about all of us.

• • • •

I come from a narrative culture—a storytelling culture. I believe in the power of

narrative. I believe in the power of memory. I believe in a certain connection between

people and the land. I believe in the consciousness and emotional lives of animals.

I believe in the soul of man.

From a conversation between Keith Carter and Bill Wittliff

Plum Creek Ranch, August 14, 1996